How to Paint
STILL LIFES

How to Paint
STILL LIFES

José M. Parramón

Watson Guptill Publications/New York

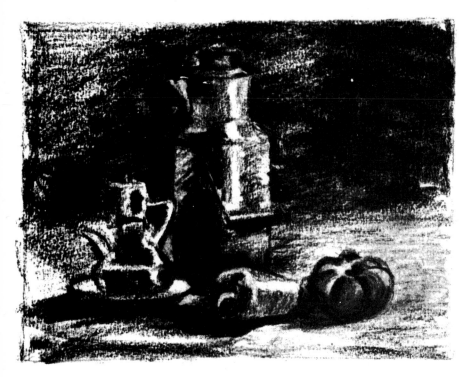

Copyright © 1988 by Parramón Ediciones, S.A.

First published in 1990 in the United States by Watson-Guptill
Publications, a division of BPI Communications, Inc.,
1515 Broadway, New York, New York, NY 10036.

Library of Congress Cataloging-in-Publication Data

Parramón, José María.
 [Bodegón al óleo. English]
 How to paint still lifes / José M. Parramón.
 p. cm.—(Watson-Guptill artists library)
 Translation of: El bodegón al óleo.
 ISBN: 0-8230-4922-1 (paperback)
 1. Still-life painting—Technique. I. Title. II. Series.
 ND1390. P2813 1990
 751.45'435—dc20 90-12549
 CIP

Distributed in the United Kingdom by Phaidon Press Ltd.,
Musterlin House, Jordan Hill Road, Oxford OX2 8DP.

Manufactured in Spain
Legal Deposit: B-28.586-90

1 2 3 4 5 6 7 8 9 / 94 93 92 91 90

Contents

2

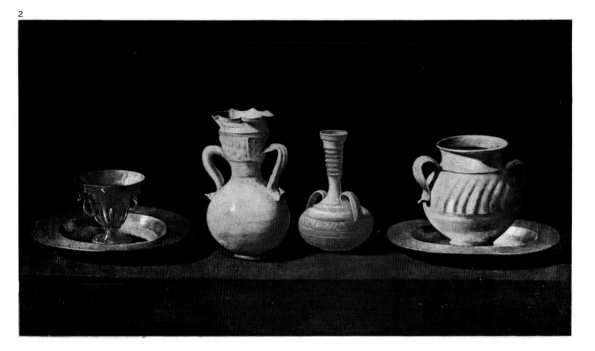

3

Fig. 1 (page 4). José M. Parramón, *Still Life*, private collection, Barcelona.

Figs. 2 and 3. From Zurbarán (Fig. 2) in 1600, to van Gogh (Fig. 3) in 1890, and up to present day (Fig 1), artists have painted ''dead nature'' or still lifes. Sometimes a still life has a specific theme, as van Gogh used to say: ''I believe that this is the best subject to copy''; and other times the still life is painted for its own sake.

Introduction

Vincent van Gogh once wrote to his brother Théo about the problem of hiring models. He needed models for his paintings, but they had to be paid, and he was very short of money. He told Théo, "I've thought about the different ways of earning a living by painting, and I've decided to teach. I am going to try to teach still life painting. I really believe that it is the best method to learn and would be better than the methods used by art teachers in general."

The still life is a good genre for teaching and learning how to paint; many artists through the centuries have used it. Francisco Pacheco recommended it to his pupils Velázquez and Zurbarán as the ideal way of learning how to paint the ordinary things of everyday life—food, fruit, pots and pans, wine carafes, and so on. Many such objects can be found in Velázquez's earlier works and, centuries later, in the works of Paul Cézanne, who deemed the still life an ideal subject to study: "This is the best way to work, using the still life as a laboratory specimen to try out new ideas, to combine and compose, to develop the visual sense or 'feeling,' and to learn how to work and arrange different components into one integrated piece of art."

Finally, the still life has been a favorite subject in schools and art colleges because painting a still life calls for the careful selection of every single object. The student can then get away from any predetermined ideas of an object's color and shape. He can choose his own objects and arrange them on a suitable base that can be used as a background. This enables the artist to create an original and pleasing unity while learning how to work on the composition of a picture. Painting a still life involves careful study of light and shadow, contrasts and color harmony, and everything in the model. Later the artist can move objects around and alter the arrangement, the colors, and the intensity of light.

Because the still life artist is painting indoors, in a studio or workshop, without someone peering over his shoulder and with all his equipment and everything he needs at hand, he has an advantage. It's necessary for the painter to concentrate hard on his work, experimenting and using all the effects of color, form, and technique; in other words, he needs to develop his style as a painter. Then he won't become a painter who works exclusively with still life, but he'll become an artist who can paint any subject he wants.

So then, that is why I've written and illustrated this book: It's meant for anyone who wants to learn and practice with oils, for anyone who wants to paint any subject in oils.

Let's start with a brief look at the origins of the still life in oil, followed by a few illustrated points on its development right up to the present day. Let's have a look at where, how, and what to paint, sorting out an arrangement, organizing the individual parts of the whole, and setting out a few basic rules about form and construction. Then we'll move on to the importance of mixing paints and some different techniques in oil painting. Finally, you'll paint some still life studies, learning through pictures the best way to go about it. If you have the ambition and want to practice, I hope that you'll be eager to paint at home for your own benefit. If I can help you to improve your techniques and teach you to paint better, particularly in oil, then I shall not have written in vain.

José M. Parramón

Since the origins of art, the representation of everyday objects in a painting was considered normal. However, until the late fifteenth century these objects were just a complement to religious, heroic, or mythological themes. Also, the first representations of still lifes as such had a symbolic meaning.

Michelangelo Merisi, also known as Caravaggio, was the first artist who used an arrangement of objects as a theme in itself. This resulted in an actual revolution in art history, since this was the first time that painting lost its religious and court character. Later on, masters such as Velázquez, Chardin, and Cézanne also painted still lifes.

4

HISTORY
──OF──
STILL LIFE

Caravaggio: A passion for life

Michelangelo Merisi was born in 1573, in a village called Caravaggio, not far from the northern Italian city of Milan.

By the time he was twelve and an apprentice to a local painter, people were already beginning to refer to him as "Michelangelo from Caravaggio." When he arrived in Rome a short time later, he was known simply as Caravaggio.

At the time of his death in 1610, he was only thirty-seven years old. A short life, indeed, like van Gogh's, but long enough to exert a profound influence on some of the greatest artists of seventeenth-century Europe: from Velázquez to Rembrandt, from Rubens to de la Tour, as well as on Ribera, Zurbarán, Le Nain, Jordaens, and Vermeer. Caravaggio's genius touched many artists. Just what was it that provoked controversial comments such as this one by Poussin: "He was born to destroy painting?" Yet others considered him the greatest master of all, even going to the extent, like Rubens, of copying his paintings.

Caravaggio changed the style of the first baroque art, introducing a new dimension into the theory of painting.

Until Caravaggio, light had had little importance in art. But Caravaggio used light to emphasize, to clarify, to explain, and many times he used the light itself as the most important theme of the painting. He was the true creator of naturalism in baroque art.

One day, Caravaggio took a little basket, filled it with a bunch of grapes, a rotten apple, some figs, pears, and a peach, and painted the first still life. This was in 1596, when he was twenty-three. It was not the first time Caravaggio had painted baskets of fruit, jugs, glasses of wine, flowers, and even books, musical scores, and instruments. It is also obvious that Caravaggio chose as real or imaginary settings for his paintings the taverns and kitchens where he often spent his time. Without realizing it, he was setting up a subject that soon would be popular in Spain and France.

Fig. 5. Caravaggio, *Basket of Fruit*, Ambrosiana Gallery, Milan. Here you see the first still life in the history of art. It's true that there had been earlier trials and errors, as you will see on the following page. But the still life as a subject in its own right, that is, the result of an artist's conscious decision to depict objects for their own sake, did not exist before Caravaggio.

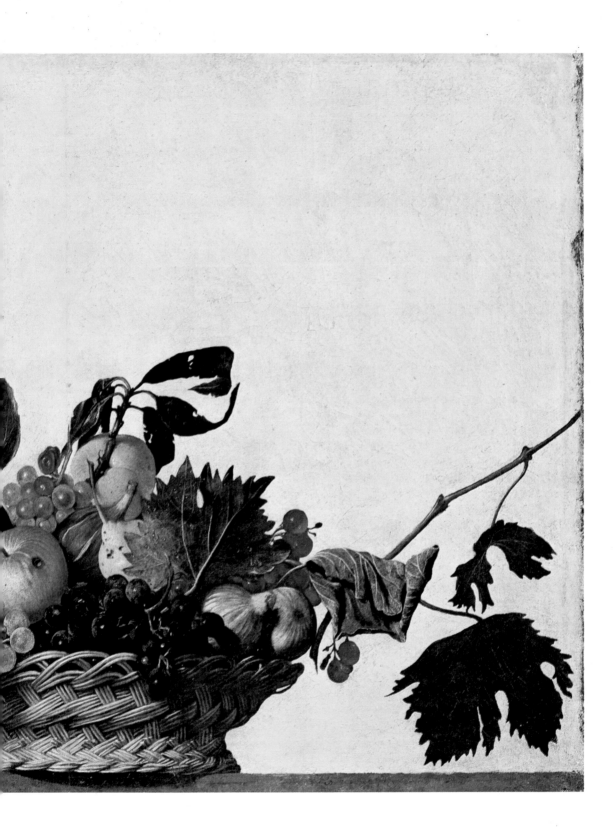

Velázquez discovers the still life

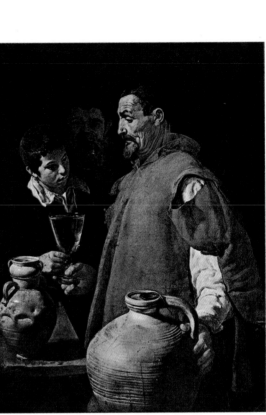

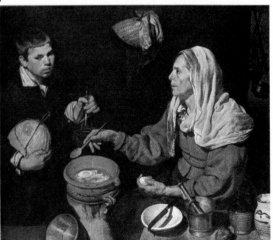

Caravaggio's unique style—painting the peasant, little dark corners of an inn, fruit and foodstuffs with rich light and unexpected contrasts—arrived in Seville, Spain, around 1592. This was at exactly the same time as Caravaggio's stay at the Consolazione hospice in Rome, where he was painting, as Mancini wrote, "... a great number of pictures for the Prior, who took them to Spain, his mother country." Seven years later, in Seville, Diego Velázquez de Silva was born. Velázquez's early paintings bear witness to the impact of Caravaggio. Velázquez began painting men and women of the street, the village peasants. He would set his characters in inns and rowdy, boisterous taverns, as well as in kitchen scenes showing tables spread with food and drink, such as in the paintings *Breakfast, The Guests,* and *Two Boys Eating.* The corner of a humble kitchen was the setting for the *Old Woman Cooking Eggs, The Servant,* and *Christ in the House of Martha and Mary.* Velázquez was about twenty when he produced these works, which the critics and the academics called *bodegones.* At that time, the Spanish word *bodegón* had a very different meaning; it was once used to describe hack art or canvases that were just daubed with paint.

In order to understand the shock and the scorn that was engendered by the paintings of Caravaggio and Velázquez, together with those of their young followers, one must remember that in the seventeenth century, painting was the most important medium of communication among the nobility, the upper classes, and scholars. Moreover, it was the information medium for society in general. What could the state and the seventeenth-century establishment say about the kind of art that portrayed heroes, gods, and saints as simple village people? In Italy, Caravaggio, in Spain, Velázquez, and in France, Louis le Nain were condemned as the "lower classes" who "degraded" art, annoying the conservatives and academics.

But, as in other times, these artists had rediscovered truth. And this was the right time for the simplicity of lowliness, "dead nature," the still life.

Figs. 6 and 7. Velázquez, *The Water Carrier of Seville,* Apsley House, London, and *Old Woman Cooking Eggs,* National Gallery, Edinburgh. Both were painted in Velázquez's so-called Seville period (1617-1622), when the artist was between the ages of eighteen and twenty-three.

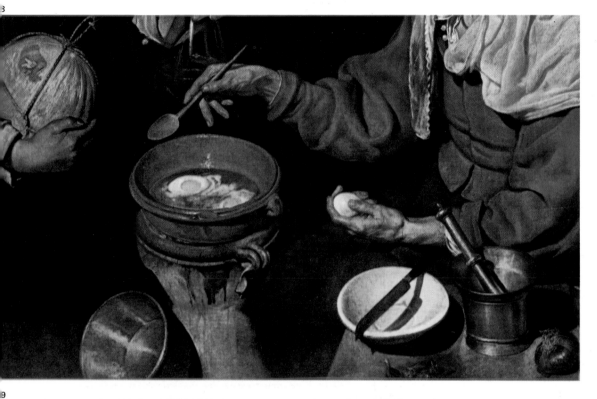

Figs. 8 and 9. Details from Velázquez's paintings *Old Woman Cooking Eggs* and *The Water Carrier of Seville*. Both are amazing examples of a still life that includes a human figure. Velázquez painted them in Seville, and these works are the contemporaries of paintings by Zurbarán, Alonso Cano, and others. Velázquez studied under Pacheco, and Caravaggio influenced them all.

When, how, why, and what?

This descriptive type of painting, portraying things about the house, flowers, fruit, foodstuff, and so on, has existed from antiquity. It was only after the Renaissance that objects began to appear as the main subject of a picture, but in the sixteenth century many artists painted figures into a scene of "dead nature," creating still lifes with figures. You can see an example here in Vincenzo Campi's *The Fruit Seller,* painted around 1560.

There are, however, three paintings that were painted earlier than the ones you see on this page that fit into the category of still life. There is a 1470 Madonna painted a century before Caravaggio by a pupil of Roger van der Weyden, a fifteenth-century Flemish painter; on its reverse is a still life, gracefully set in a niche, incorporating several objects associated with the Annunciation.

There is also a well-known picture, *Vase of Flowers in an Alcove,* painted in 1490 by Hans Memling, a Flemish artist. Strangely, this was also painted on the back, in this case of a portrait.

Finally, there is the *Dead Bird,* painted around 1504 by the Venetian artist Jacopo de Barbari.

These paintings are isolated trials and experiments that cannot really be called still life in the present meaning of the word as it was so clearly defined by Caravaggio.

Fig. 10. Vicenzo Campi, *The Fruit Seller,* Brera Gallery, Milan. This work, painted around 1560, belongs in the genre of still life with figures.

10
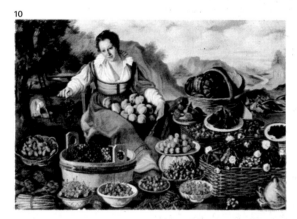

11

Figs. 11 and 12. Hans Memling, *Vase of Flowers in an Alcove,* Thyssen Collection, Lugano (Fig. 11). Jacopo de Barbari, *Dead Bird,* Gallery of Early Paintings, Munich, (Fig. 12).

12
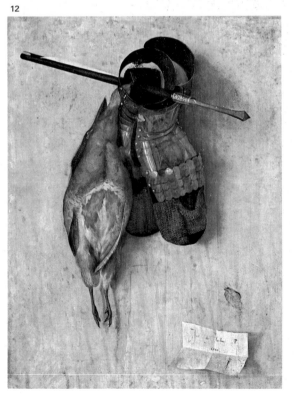

Subjects of early still life

Still life as we know it first saw the light of day in the Netherlands and, at the same time, in Italy toward the end of the sixteenth century. In southern Europe, it grew from the talent of Caravaggio. In the north, perhaps, it was the logical result of the Reformation, which, having downgraded religious art, must have left artists looking for something else to paint.

By the beginning of the seventeenth century, three basic types of still life had been developed. One of them, known as *vanitas,* was intended to be a reminder of the transience and impermanence of life, with the specter of death just around the corner. The human skull was used as a symbol of death and of the hereafter, as in Fig. 13. This painting shows a candle burning down to nothingness and an hourglass, both reminding one of the brevity of life, an impermanence shared by material things.

Soon afterward a symbolic type of still life came into being, somehow representing the five senses: sight, sound, touch, taste, and smell. The senses were linked to religious or nature symbols, such as fire, wind, and water. This so-called symbolic still life reappeared much later, in the eighteenth century, in painting, sculpture, and literature.

Figs. 13 to 16. Four early still life paintings with various subjects: Fig. 13. D. Lhome, *Vanitas*, Troy Collection. Fig. 14. J. Linard, *The Five Senses and the Four Elements*, Fine Art Museum, Algiers. Fig. 15. Jean-Baptiste Siméon Chardin, *Paraphernalia of Art*, Louvre, Paris. Fig. 16. Louis Tessier, *Arts and Sciences*.

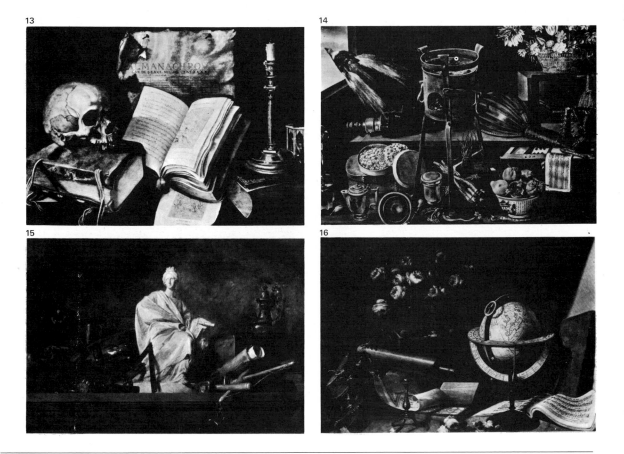

13

14

15

16

Virtuosity and "trompe l'œil"

The third type of still life used the chosen objects to bring out the painter's skill. In this type of painting, flowers, fruits, pitchers, and baskets abounded. At the beginning of the seventeenth century, little insects and tiny creatures such as beetles, butterflies, snails, and minute lizards were included in still life paintings. By introducing these elements, the artist tried to prove his virtuosity and to deceive the eye. The cultivation of this illusion (for example, making an insect settling on a piece of fruit or on a tabletop seem "real" to the viewer, not just painted on) led, in the middle of the seventeenth century, to a form of art called *trompe l'œil,* a French expression meaning "deceiving the eye."

In modern art, *trompe l'œil* reappears as superrealism in still life. It's used by Ken Davies in the United States, David Hockney in England, Sciltian in Italy, and many, many more artists.

17

18

Fig. 17. A typical *trompe l'oeil* by J.F. De La Motte from a private collection in France. The artist used the effects of relief, detail, and an illusionary technique to the maximum in a way that was characteristic of the subject and style. This type of painting is still being done by some North American artists, as well as by some contemporary superrealists.

Fig. 18. Claude Vignon, *Peaches and Grapes* (detail), J.R. Collection, Paris. Here is an example of an early treatment of the still life theme, showing virtuosity but painted with no intention of symbolism. The French painter Claude Vignon demonstrates his mastery by including insects that are painted in miniature and in perspective.

Sixteenth to seventeenth centuries

At the end of the sixteenth century, some of the most outstanding still lifes were created by the Dutch painters Jacobo de Ghent and Balthasar van der Ast; the Flemish master Jan Brueghel the Elder; the Italian painter Caravaggio; and the Spanish painter Sánchez Cotán. Soon afterward Jacques Linard and Louise Moillon came to the forefront in France, and van Schooten became esteemed in Holland.

The marked similarity in composition is apparent from the illustrations on this page. Notice how the objects are not merely painted in pieces but in a group, or rather a heap. The merits of a simple arrangement using fewer and more diverse elements, as Caravaggio had already achieved in his famous *Basket of Fruit,* had not yet been appreciated.

Fig. 19. Louise Moillon, *The Fruit Vendor,* private collection. New York.

Fig. 20. Sánchez Cotán, *Still Life with Fruit and Artichokes,* Victor Spark Collection, New York.

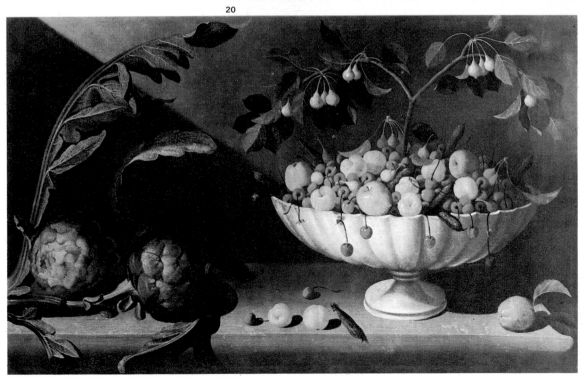

The seventeenth century

During the seventeenth century, Dutch and Flemish painters dominated still life painting. In Holland, Pieter Claesz, Alexander Coosemans, Jan de Heem, van de Velde, and others, especially Willem Heda, painted marvelous still lifes. Van Soon, Jan Fyt, and Clara Peeters were among those who raised the level of artistic achievement in Flanders. And in Spain, Zurbarán and Velázquez discovered the potential of the still life and painted wonderful pictures, such as *The Water Carrier* and the famous *Vessels on a Cloth,* while Juan de Valdés Leal painted his *Vanitas* and Felipe Ramírez followed the school of Sánchez Cotán.

In France, Lubin Baugin, Stoskopff, and Dupuisy were among the successful interpreters of the theme of *nature morte,* from a simple picture with two or three elements to the elaborate and stylized content of grandiose paintings, from the subject of "transience" to the simple still life with a few carefully arranged pieces of fruit.

Fig. 21 . L. Baugin, *Still Life with Chessboard,* Louvre, Paris. This is a good example of a "symbolic" still life. The subject seems to be a portrayal of the five senses, the mandolin and music score representing hearing; the purse, cards, and chessboard indicating touch, the mirror (background, right) for sight; the carnations for smell; and the bread and wine for taste.

Fig. 22. Willem Heda, *Still Life,* Prado, Madrid. Heda was indoubtedly one of the greatest seventeenth-century Dutch painters of still life. It has been noted that Heda's paintings possess three essential factors of the art of composition: a) selection of subject matter based on elements of definite geometric shapes, exhibiting the principle of unity and coherence; b) use of a diagonal arrangement, arrested by a tall, elegant vessel or some other element; c) careful color harmonization.

21

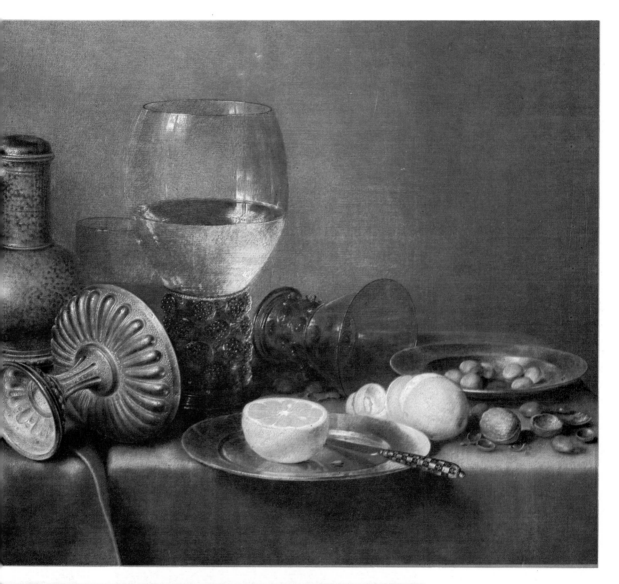

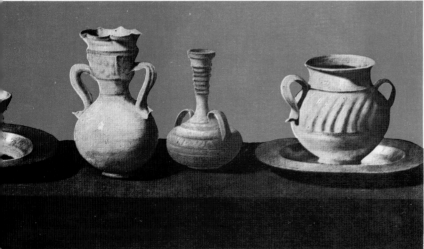

Fig. 23. Francisco Zurbarán, *Still Life*, Prado, Madrid. A contemporary and friend of Velázquez, Zurbarán was a student of Herrera the Elder in Seville, where in his youth he painted this famous still life with wine jugs. This picture, one of the most famous still lifes in Spanish classical painting, is remarkable in its simplicity (reminiscent of Sánchez Cotán). The well-contrived illusion of volume and the arrangement of the pottery defy the rule of "unity within variety."

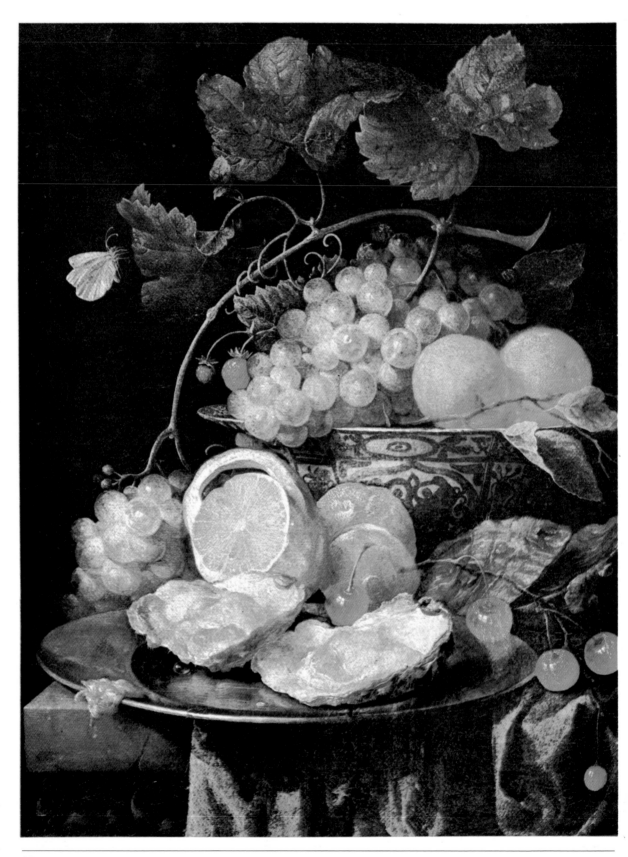

The eighteenth century

Fig. 24. Joris van Soon, *Still Life*, Prado, Madrid. Van Soon was a Flemish painter with a disciplined and balanced style, as portrayed in this painting. Note how the composition reflects the beginning of the trend toward simplicity, gradually moving farther away from the baroque style. The butterfly motif is fre- quently found in the still lifes of that time (mid-seventeenth century).

Fig. 25. Anne Vallayer-Coster, *White Tureen*. Anne Vallayer-Coster might reasonably be rated the best French still life painter of the seventeenth and eighteenth centuries. She was admitted to membership of the Royal Academy of Painting and Sculpture at the age of twenty-six. She was compared with Chardin, summoned to court to paint portraits of the queen, and acknowledged by contemporary critics and painters as an exceptionally great artist.

France became the main center of influence in eighteenth-century western art. The golden age of still life flourished there. Artists looked to nature as an art form, producing works of outstanding merit and following the example set by Jean Chardin, the famous French painter. Some examples of his work are shown on page 22. Many of his contemporaries contributed toward the establishment of still life as a successful subject; two of these were Jean-Baptiste Oudry and Dorothée Anne Vallayer-Coster.

One of Holland's most notable painters was Justus van Huijsum, who is celebrated for his flower paintings and his innovations in composition. At the same time, art in Spain was in a decline, the exception being the still lifes of Luis Meléndez.

25

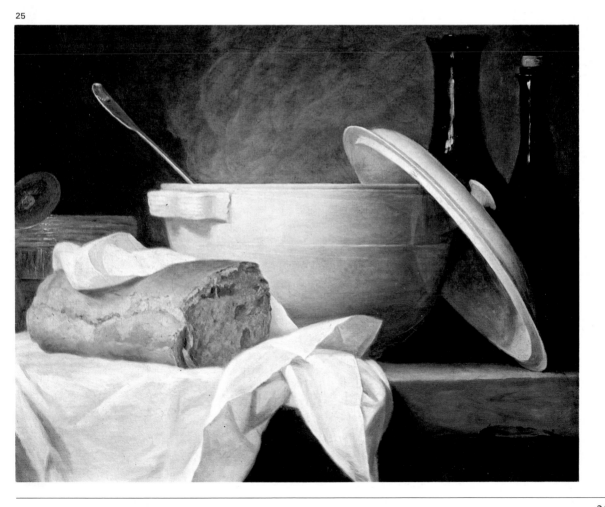

Jean-Baptiste Siméon Chardin

26

27

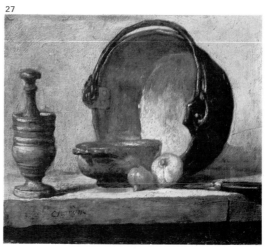

28

You have only to look at the paintings by Chardin reproduced here to realize immediately that you are viewing the work of a consummate artist. Early on, Chardin moved back and forth between still lifes and portraits. His most renowned paintings are *Lady Sealing a Letter, Woman Scrubbing, The Cook,* and his famous *Self-Portrait with Visor.*

With his great skill, Chardin had the intelligence and courage to turn away from overly ornate subjects. He replaced artificial scenes with the beauty of the real world. On this page, there are some excellent examples of works by Chardin.

Fig. 26.. *Copper Urn,* Louvre, Paris.

Fig. 27. *Copper Pan,* Louvre, Paris.

Fig. 28. *Bunch of Flowers,* National Gallery of Scotland, Edinburgh.

Nineteenth and twentieth centuries

Since the nineteenth century, still life painting has been a much-cultivated art, practiced fairly assiduously by almost all the world's leading artists: Delacroix, Courbet, Manet, Monet, Renoir, van Gogh, Picasso, Matisse, Braque, Juan Gris, Dalí, and, last but not least, Cézanne, the most important still life painter of this time. Later, you'll see his sketches and paintings, and I hope you'll learn and benefit from them.

30

29

31

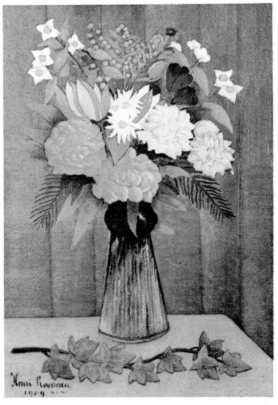

Fig. 29. Gustave Courbet, *Apples and Pomegranates,* National Gallery, London. This quiet, unpretentious picture was painted in 1871 while Courbet was serving a prison sentence in Paris for his alleged involvement in the Vendôme Column affair when he was president of the Paris Assemblée d'Artistes.

Fig. 30. Henri Fantin-Latour, *Still Life with Dahlias and Hydrangea,* Toledo Museum of Art, Ohio. In 1866, the French artist painted this exquisite picture. It was four years before the first impressionist exhibition. Although Fantin-Latour was friendly with many of the impressionists, he continued to paint in the academic realist style.

Fig. 31. Henri ("Le Douanier") Rousseau, *Vase of Flowers,* Albright-Knox Art Gallery, Buffalo, New York. Here is an example of a still life in a style halfway between realism and "primitive," a style of painting defined as naïve, spontaneous, and childlike. Rousseau was a genuine primitive artist; fortunately, despite his efforts to paint "well," he was unable to alter his style—which has since been judged as "better than well."

Cézanne

32

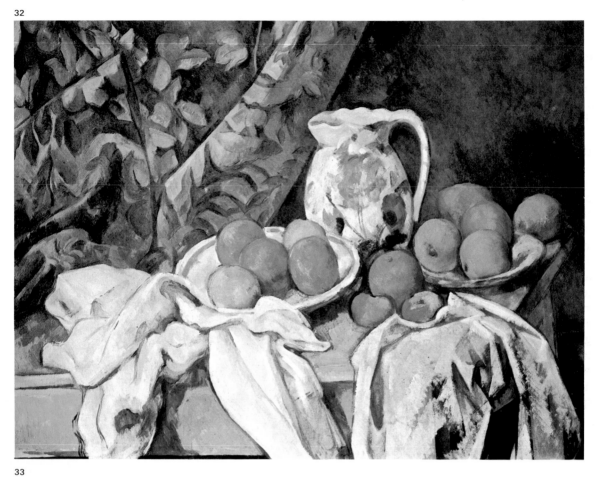

33

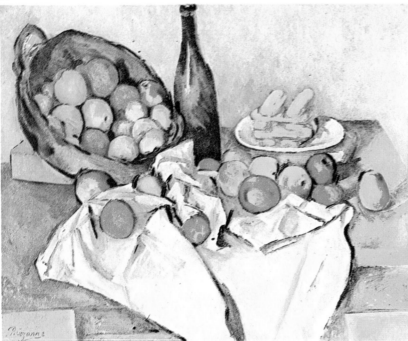

Fig. 32. Paul Cézanne, *Still Life with Curtain and Flowered Pitcher*, Hermitage Museum, Moscow.

Fig. 33. Paul Cézanne, *Still Life with Basket of Apples*, Institute of Art, Chicago. Cézanne was remarkable in his arrangement of a painting's components. Although apparently haphazard, his setups were actually the result of hours of careful study.

The twentieth century

I have come to the end of my brief summary of the history of still life, and I'll close with just two pictures that may be regarded as "modern" works within the scope of realism. They are not intended to be representative of twentieth-century still life paintings.

The first picture is by van Gogh, the other is by Nonell. The first is strikingly coloristic, composed of flat colors giving form without volume, lacking any pattern of light and shadow. At the time, this was a new style, an individual and masterly method of painting.

The second picture, by the Catalan artist Isidro Nonell, relies on the masterly handling of values. Using a fluent treatment and creating outlines with brushstrokes, he carefully expressed volume with shadows, local colors, and highlights. This was also a unique style for that time.

Later, I'll discuss both color and value, and you'll examine their practical aspects.

34

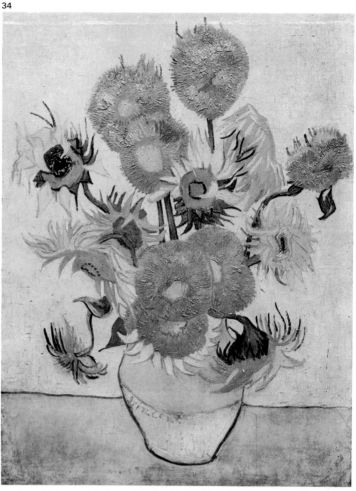

35

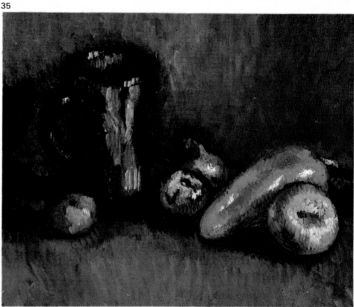

Fig. 34. Vincent van Gogh, *Vase of Sunflowers*, Rijksmuseum, Amsterdam.

Fig. 35. Isidro Nonell, *Still Life*, Museum of Modern Art, Barcelona.

Now we are going to deal
with the materials and the
tools that you will need to
paint a still life. First, I must
mention the studio. Without
one, you cannot paint still
lifes; it must be a workable
size, and comfortable. The
second factor is lighting.
Natural light must come
through at least one large
window, and artificial light
must be controlled so that it
illuminates the still life in a
way that will create contrasts
and chiaroscuro. Third, you
need an easel, a canvas, a
portfolio, brushes, and tubes
of oil paint. Let's go into it.

STUDIO
—AND—
MATERIALS

The studio

In April 1904, Pablo Ruiz Picasso came to live in Paris for the second time. A month earlier Paco Durio, a sculptor, had written Picasso to say that he was leaving a studio in Paris, on the slopes of Montmartre, number thirteen, rue de Ravignan (now called Place Emile Goudeau). "Plain, cheap and in a very pleasant part of the city," was the description given to Picasso by his friend.

Cheap, certainly, but plain most of all; the studio was in a dilapidated old wooden tenement building inhabited by artists, writers, actors, washerwomen, and prostitutes. Picasso joked with friends that in the stormy autumn winds, the dreadful building pitched and tossed like a sailing ship. The poet Max Jacob dubbed the building the Bateau-Lavoir ("floating laundry"), which was the popular nickname for the old wooden stages moored in the Seine from which people used to do their wash. The name stuck and came into general use to describe Picasso's studio.

What was it really like, this famous Bateau-Lavoir? From 1905 to 1909 it became one of the frequent Paris meeting-places for artists, poets, and writers, including such notables as Braque, Dufy, Utrillo, Rousseau, Cocteau, Apollinaire, and Max Jacob.

In her book *Extraits de Picasso et ses amis,* Fernande Olivier, Picasso's first mistress, describes the Bateau-Lavoir: "An icebox in winter, an oven in summer. A place redolent of work and jumble: a divan bed in one corner, a rusty little iron stove on which stood an earthenware tub used as a washbasin, beside it an unpainted wooden table, a towel and some soap. In another corner a battered black trunk served as an uncomfortable seat. A straw-bottomed chair, easels, canvases of all sizes, paint tubes scattered about the floor, brushes, jars of turpentine, no curtains..."

37

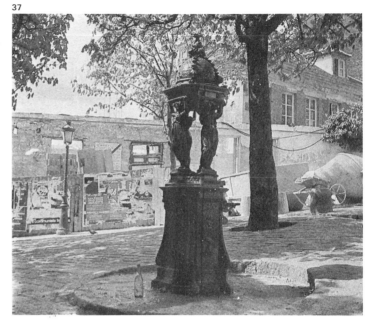

Fig. 37. A recent photograph of Place Emile Goudeau, on the slopes of Montmartre. In the background, behind the lamp-post, and half-hidden by the fence, is the top of the Bateau-Lavoir, Picasso's studio in the 1900s. The Bateau-Lavoir has been in ruins thanks to a fire a few years ago, but a new building is now being erected. The square and the fountain where Picasso first met Fernande Olivier are unchanged. Picasso arrived at the Bateau-Lavoir in 1904 and moved out in 1909. During those five years, his studio was a meeting-place for all the leading young artists of the day. Most of the pictures in his "blue" and "rose" periods were painted there.

39

Figs. 39 and 40. Nowadays a painter's studio might look like this. The top floor of any house or flat usually has plenty of natural light. Ideally, it should be a room that can be divided into areas for painting, reading, entertaining visitors, listen-

38

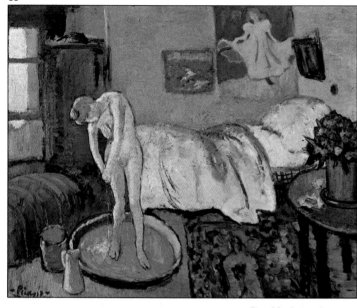

Fig. 38. Pablo Picasso, *The Blue Room* (1901), The Phillips Collection, Washington. The room is based on his Paris lodgings in Boulevard Clichy. Its smallness did not hinder Picasso from painting this and several other pictures at the beginning of his "blue" period.

40

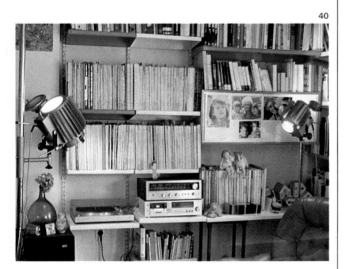

ing to music, and so on. As these photographs show, the studio need not be very large.

"To support all this, a floor of rotting planks," adds one of Picasso's biographers.

The Bateau-Lavoir studio was really quite big—up to fifteen people at a time would meet there to discuss art. It must have been larger than the room Picasso rented in Boulevard Clichy during his earlier stay in Paris in 1901. Judging from Fig. 38, the studio could not have been larger than $13' \times 16'$ (4×5 m).

Despite conditions in the small room in Boulevard Clichy and the wretched Bateau-Lavoir, Picasso produced the celebrated paintings of his "blue" period, a marvelous series now considered to be among his best works.

These details about Picasso's studios show that surroundings need not necessarily affect the speed of the creative process involved in painting. All the same, certain minimum facilities—space, light, and materials—are necessary. Let's consider some factors, first the minimum dimensions needed for a studio, though many amateurs may have to use their living rooms.

A painter's studio needs to be only about $13' \times 11\frac{1}{2}'$ (4×3.5 m); of course, a larger room is better.

From my knowledge of painters' studios, I am sure these measurements are suitable. I painted for several years in a studio with an area $13' \times 16'$ (4×5 m), and I now work in a room measuring $26\frac{1}{4}' \times 10\frac{3}{4}'$ (8×3.30 m), half of which is used for reading, writing, chatting with friends, or listening to music.

Your workroom should have natural light. But see the next page for more about this.

The importance of light

Most painters work by daylight, but there is no reason why they should not paint by artificial light if they wish. Many professionals often work on two paintings concurrently, one in the morning, by daylight, and the another after dark, by artificial light. This is nothing new. In 1600, Caravaggio studied and painted his models by candlelight (hence his strong contrasts). A short time earlier, in 1586, El Greco arranged draperies, dummies, and live models in his studio and worked by candlelight. His marvelous paintings, including *The Burial of Count Orgaz,* were painted at night. Picasso regularly painted late at the Bateau-Lavoir, using the blue gaslight for the lighting he needed. This at least partly explains the predominance of blues in his paintings and, indeed, his famous "blue" period.

A studio should have at least one large window for painting by natural light, giving the model a lateral-frontal or lateral lighting.

Painting by artificial light calls for two sources of light, one to illuminate the model and another to light the work. And there should be another lamp for lighting the entire room.

The light for the model can be a 100-watt bulb in a wide-shaded lamp, so that the painter can avoid the sharp focus and excessive contrast produced by direct lighting. For still life painting, the lamp should be about 31½"-39½" (80-100 cm) away from the work; this is usually the best distance for good illumination of the model.

The painting itself needs light projected from above, preferably from a flexible or extending lamp. Again, use a 100-watt bulb.

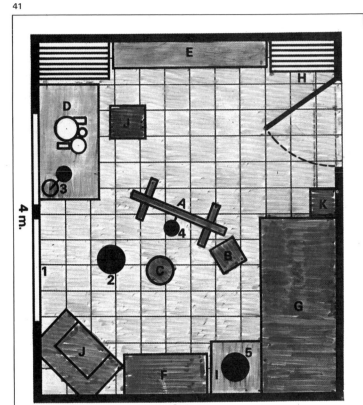

Lighting and studio equipment

1. Window or light source in the external wall
2. General lighting (artificial)
3. Table lamp, to illuminate a still life
4. Easel light, above the painting
5. Extra light for an additional table

This studio measures 11½' × 13' (3.5 × 4 m) and includes the following equipment, which you will learn more about on the following pages.
a. Studio easel
b. Small extra table
c. Painting stool
d. Rectangular table for still life subject and for preparation of quick roughs
e. Bookcase
f. Record cabinet
g. Studio couch
h. Space for storing used and unused canvases
i. Extra working surface
j. Armchairs
k. Upright chairs

Fig. 41. The diagram gives you a basic idea of the minimum dimensions for a studio and the placement of the lighting and fundamental equipment.

It's important to use two bulbs of the same strength, so that the lighting of the work is not too strong compared with that of the model, or vice versa. This might cause the artist to apply colors that are paler or darker than he wants. Finally, the general light should be set near the ceiling; it can be 60 or 100 watts (depending on the size of the room). Make sure that the general light does not project extra shadows that will affect the lighting of the model and exaggerate the highlights.

Figs. 42 to 45. Natural diffused light softens the forms of objects; artificial light (direct light) accentuates the contrasts.

Fig. 46. In this case, the easel must be illuminated from the left. This picture shows how to position the easel and the model.

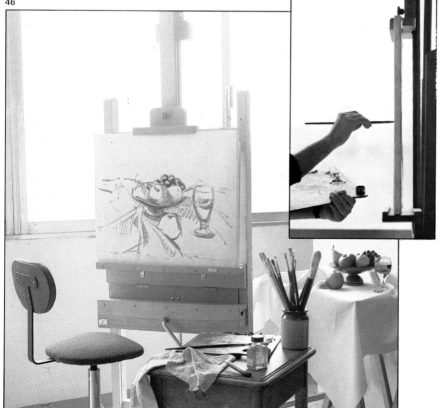

Fig. 47. Artificial light can overreflect; this is especially noticeable when the paintbrush is held in a horizontal position, so be careful.

Fig. 48. You can get rid of the reflection by lowering the light, tilting the canvas, and using the brush in a diagonal or vertical position.

The studio easel

You'll need various items for your studio. The ones listed below are in order of importance:

• Easel
• Work table for painting
• Stool
• Table for the still life or for drawing
• Chairs and a sofa
• Bookcase
• Portfolios

Now I'll begin with the easel. There are two kinds of easels for oil painting, one for painting outdoors and one for studio work. The former is the usual three-legged folding easel, suitable for outdoor painting. If you are a novice, you may find it better to use an outdoor easel for studio painting at home, provided that you realize that its thin legs may collapse. But a studio easel is stable enough to withstand both nervous dabbing and vigorous brushstrokes.

Here and in the following pages, you will see an outdoor easel as well as some of the more common types of studio easels.

Fig. 49. Conventional outdoor easel. It is not big enough to take large canvases. For this reason, and because of its poor stability, it's not recommended as a studio easel.

Fig. 50. Tripod studio easel. It's about $5\frac{1}{2}'$ (1.70 m) high and can be used with canvases of up to $39\frac{3}{8}'' \times 31\frac{7}{8}''$ (100 × 81 cm) in dimension. This is the type commonly used in art colleges.

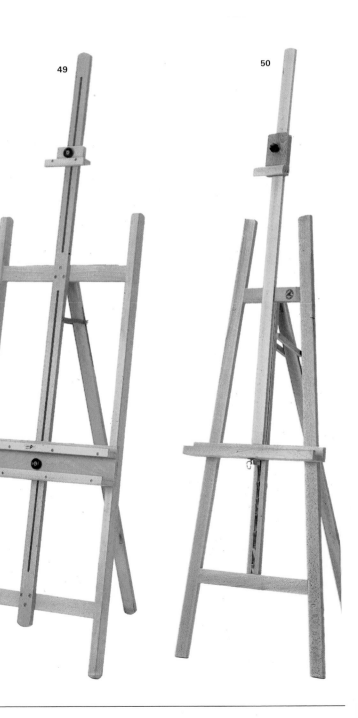

49

50

Fig. 51. This is the most common studio type for the professional artist. It stands on a firm frame of wooden supports mounted on four casters, for easy movability or adjustment. It has two ledges, one to hold the canvas and the other to hold paint tubes, brushes, spatulas, etc, when in use. The height of the ledges can be adjusted according to need; the central support also has an adjustable height clamp or locking bar that holds the canvas in place.

Fig. 52. Almost the same as the previous example, this easel is a little larger. There is a double-arm central support that can tilt the canvas to avoid reflection. This easel is designed for larger paintings.

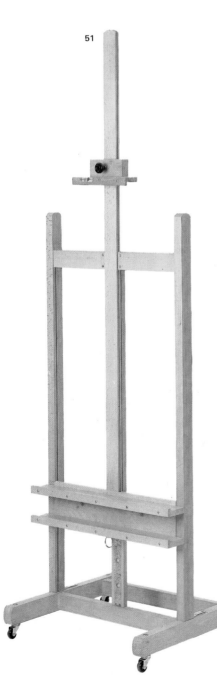

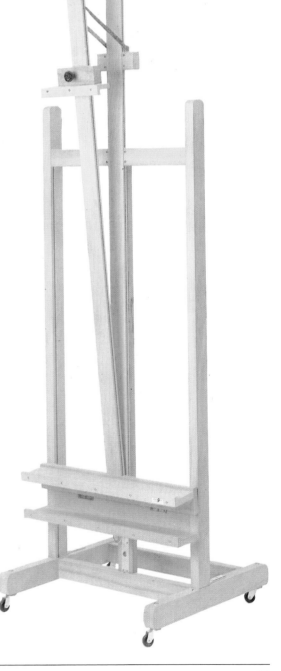

Furniture and tools

A painter working in his studio needs some kind of small work-table to put beside the easel while he works. In art supply stores, you may be able to find an all-purpose stand (Fig. 54). The one in the photograph is on casters, so that the painter can easily move it around the studio and bring it right beside the easel when he is painting. It's very useful because you can store your paints, rags, paintbrushes, and palette and have quick access to all the necessary materials. The top of this stand is divided into compartments; there are drawers that swivel out to provide trays or additional surfaces and shelves for bottles, tins, pots, rags, and so on.

53

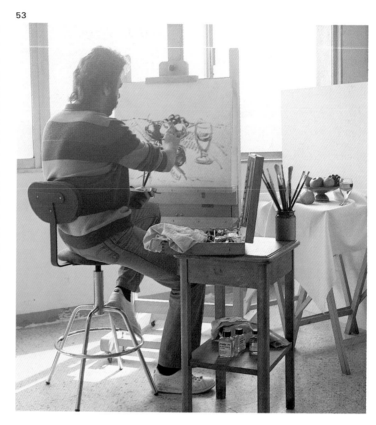

54

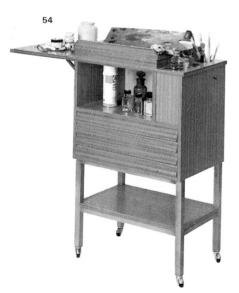

55

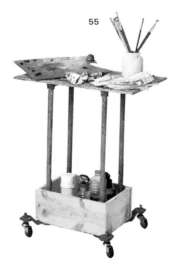

56

Fig. 53. In this photograph, you can see an easel with an extending arm, a swivel stool with backrest, and a small extra worktable.

Fig. 54. You may be able to buy this type of stand in an art supply store. It has drawers and trays which swivel out and compartments or shelves for everything the painter needs: tubes of paint, brushes, spatulas, bottles, rags, and so on. It can be moved around easily on its four casters. Perhaps its only fault, apart from the high price, is the lack of a flat working surface.

Fig. 55. For years I have used a small worktable made from an old typewriter trolley, like this.

Fig. 56. You'll need at least two portfolios in the studio, for storing paper and finished work. A portfolio rack like this one is very useful. You can purchase them from art supply shops.

Figs. 57 and 58. Right: stool with adjustable backrest, seat, and footrest. Left: conventional wooden stool with adjustable seat.

Fig. 59. A wooden block such as this one can convert a table into a desk; it makes drawing and sketching less tiring.

You can use an ordinary small table or stand if you wish. Some time ago I converted an old typewriter trolley for this purpose, fixing a board over the top and adding drawers below, as shown in Fig. 55.

The artist's stool is usually fairly high, so that he can sit comfortably or lean forward. If you have a choice, it's a good idea to get one on casters, with an adjustable backrest, an adjustable upholstered seat and a footrest as shown in Fig. 58.

Other than this very practical seat, there is the conventional three-legged wooden stool with adjustable seat, which can be made more comfortable with a small flat cushion (Fig. 57).

A studio also needs an ordinary table about 55″ × 31½″ (140 × 80 cm), large enough to display a still life subject. It can also be used for drawing, either by propping a drawing board against it or by adding a simple wooden block on top of it, to change it into a desk (Fig. 59).

A bookcase is vital—every artist needs a small library of books on drawing and painting, art, and art techniques to broaden his knowledge and refresh his memory.

In the studio, there must also be some portfolios, at least two large ones, to store drawing paper and finished work.

57

58

59

Canvases and boards for oil painting

The surfaces most used for oil painting are linen, cotton, or hemp canvases. A canvas is mounted on wooden stretchers and then prepared with the application of a coat of paint called *primer*. Canvas can be primed merely by applying a coat of acrylic white, but it's not a good idea to do this yourself—it's a job for the specialist.

Art shops sell excellent prepared canvases in a range of surfaces, from rough to smooth, to suit the style of painting. Don't use rough-grain canvas for small pictures.

Since prepared canvases are sold mounted on wooden stretchers, the tautness depends on how four small wedges are tapped into the four corners of the stretcher frame. Prepared canvas is also sold in various sizes.

For small pictures, canvas board (cloth-covered cardboard) or a prepared laminated wooden panel can be used. In an emergency, an ordinary piece of good quality, thick cardboard can be primed by thoroughly sizing the surface or by applying a coat of oil paint thinned with turpentine. You can paint on unprimed cardboard canvas, or wood, but the oil colors will be absorbed; you will lose the quality of the colors, and the painting process takes longer. Good quality thick drawing paper will take oil paints quite well.

Canvases, canvas boards, and wooden panels are sold in a range of sizes. There is an international table of sizes, classified by subject—figure, landscape, or seascape—so that an artist can choose among various sizes in three different proportions. The "figure" canvas is squarer than the "landscape," and the "seascape" is the widest in relation to its height.

INTERNATIONAL SIZES OF OIL PAINTING STRETCHERS

Nos.	Figure		Landscape		Seascape	
1	8⅝″×6¼″	(22×16 cm)	8⅝″×5½″	(22×14 cm)	8⅝″×4¾″	(22×12 cm)
2	9½″×7½″	(24×19 cm)	9½″×6¼″	(24×16 cm)	9½″×5½″	(24×14 cm)
3	10⅝″×8⅝″	(27×22 cm)	10⅝″×7½″	(27×19 cm)	10⅝″×6¼″	(27×16 cm)
4	13″×9½″	(33×24 cm)	13″×8⅝″	(33×22 cm)	13″×7½″	(33×19 cm)
5	13¾″×10⅝″	(35×27 cm)	13¾″×9½″	(35×24 cm)	13¾″×8⅝″	(35×22 cm)
6	16⅛″×13″	(41×33 cm)	16⅛″×10⅝″	(41×27 cm)	16⅛″×9½″	(41×24 cm)
8	18⅛″×15″	(46×38 cm)	18⅛″×13″	(46×33 cm)	18⅛″×10⅝″	(46×27 cm)
10	21⅝″×18⅛″	(55×46 cm)	21⅝″×15″	(55×38 cm)	21⅝″×13″	(55×33 cm)
12	24″×19⅝″	(61×50 cm)	24″×18⅛″	(61×46 cm)	24″×15″	(61×38 cm)
15	25⅝″×21¼″	(65×54 cm)	25⅝″×19⅝″	(65×50 cm)	25⅝″×18⅛″	(65×46 cm)
20	28¾″×23⅝″	(73×60 cm)	28¾″×21¼″	(73×54 cm)	28¾″×19⅝″	(73×50 cm)
25	31⅞″×25⅝″	(81×65 cm)	31⅞″×23⅝″	(81×60 cm)	31⅞″×21¼″	(81×54 cm)
30	36¼″×28¾″	(92×73 cm)	36¼″×25⅝″	(92×65 cm)	36¼″×23⅝″	(92×60 cm)
40	39⅜″×31⅞″	(100×81 cm)	39⅜″×28¾″	(100×73 cm)	39⅜″×25⅝″	(100×65 cm)
50	45⅝″×35″	(116×89 cm)	45⅝″×31⅞″	(116×81 cm)	45⅝″×28¾″	(116×73 cm)
60	51⅝″×38¼″	(130×97 cm)	51⅛″×35″	(130×89 cm)	51⅛″×31⅞″	(130×81 cm)
80	57½″×44⅞″	(146×114 cm)	57½″×38¼″	(146×97 cm)	57⅛″×35½″	(146×90 cm)
100	63¾″×51⅛″	(162×130 cm)	63¾″×44⅞″	(162×114 cm)	63¾″×38¼″	(162×97 cm)
120	76¾″×51⅛″	(195×130 cm)	76¾″×44⅞″	(195×114 cm)	76¾″×38¼″	(195×97 cm)

60

61

Fig. 60. Here are the comparative relationships among the three proportions: F (Figure), L (Landscape), S (Seascape).

Fig. 61. A stretcher consists of four pieces of wood joined together, so that when the canvas is mounted it can be tautened using four small wedges pushed into slots in the inside corners of the stretchers.

How to make a stretcher

Obviously, it's more convenient to buy a ready-made stretcher than to make it yourself. But you may live a long way from the art store, or you may waste a canvas, which happens frequently, and have an empty stretcher.

In both cases, it is useful to learn how to make a stretcher and to mount the canvas.

You will need four pieces of wood, some wood wedges, a pair of wide, flat pliers to pull the canvas taut, a stapler, a hammer, and a saw.

Study the photographs.

Fig. 62. These materials are necessary to make a stretcher: A, pieces of wood; B, wood wedges; C, special pliers for tautening the canvas; D, a stapler; E, staples; F, a hammer; G, a saw.

Figs. 63 and 64. Stretchers are joined together. The pieces are narrower in their inner side (B) than in their outer side (A). This difference in the width affects the side covered by the canvas; it prevents the canvas from getting damaged.

62

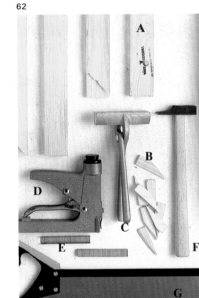

63

64

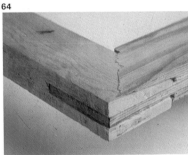

65

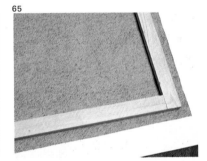

66

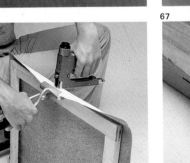

67

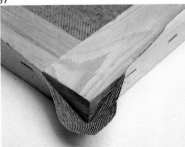

Fig. 65. Once the stretchers are mounted, the canvas is cut about $1\frac{1}{2}''$ (4 cm) oversize on all edges.

Fig. 66. Staple the canvas on one side, tauten it with the pliers and staple the rest of the stretcher.

Fig. 67. Pull the canvas taut and fold it at each corner.

Figs. 68 and 69. This is the way you must fold the canvas at each corner. Then, staple down the remaining canvas on each side (Fig. 69). Tap the wedges in the corners as in Fig. 69.

68

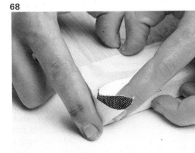

69

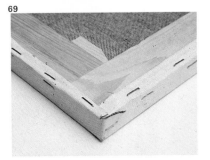

Brushes for oil painting

The brushes most commonly used for oil painting are made of hog bristle. You can also use sable brushes to paint in small details, draw lines, form outlines and so on. Bristle brushes are made in three different shapes; in art stores they are called "round," "flat," and "filbert." In some countries, you can still find a fan-shaped brush that is made especially for overpainting with transparent paint, blending shape or color in problem parts of a painting. Sable brushes come round or flat. Brushes for oil painting are long 11″ to 11⅛″ (28 to 30 cm). The thickness of the tip of bristle brush varies according to the number on the handle. These numbers run from 0 to 24, using even numbers after no. 1 (1, 2, 4, 6, 8, 10, etc.). For oil painting you need an assortment of about fifteen brushes.

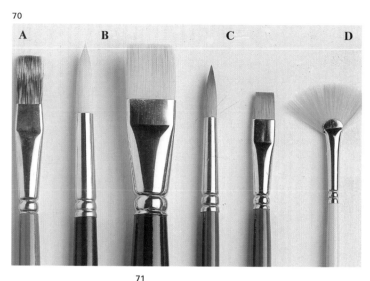

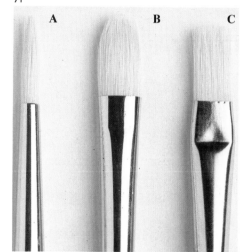

Fig. 70. Oil painting brushes: A, mongoose brush; B, synthetic brushes; C, sable brushes; D, fan-shaped sable brush for very soft blendings.

Fig. 71. Three shapes of the bristle brush, the most commonly used brush for oil painting: A, round tip; B, filbert tip; C, flat tip.

Fig. 72. Complete assortment of bristle brushes, from 0 to 24.

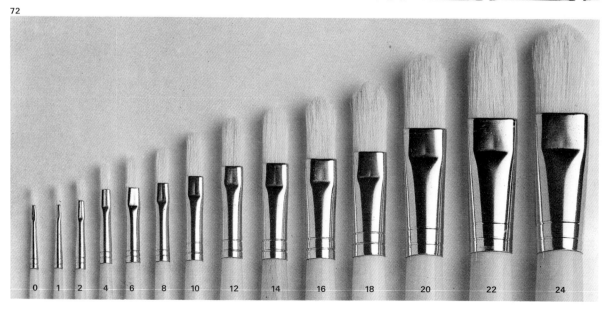

73

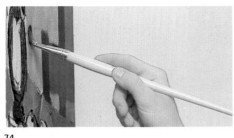

74

75

Figs. 73 and 74. Here are two ways to hold a brush: (above) holding it straight and painting horizontally; (below) holding the handle of the brush along the palm, painting vertically.

Fig. 75. This picture shows the common way of holding the brush while working with oils. It is basically the same way you hold a pencil but farther from the tip. With the brush in this position, you can paint in a freer, more flowing way and enjoy a wider overall view of the painting as it develops.

76

77

78

79

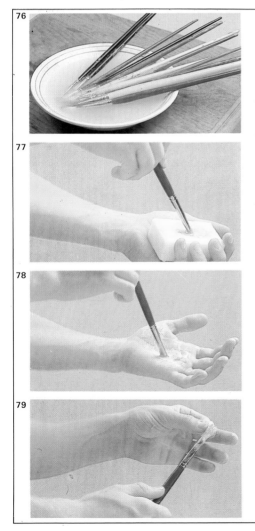

Figs. 76 to 79. You should take care of you brushes. A used brush kept in good condition paints better than a new one. If you are going to continue your painting the next day, you needn't clean the brushes thoroughly; just rinse them in turpentine and wipe them with a rag. In an emergency, you can leave them a day longer in a dish or jar with the bristles submerged in water. But it's always better if you can thoroughly wash the brushes immediately after use. The best method is with soap and water, rubbing the bristles on a piece of soap and then on the palm of the hand, rubbing and wiping round and round, rinsing with water, soaping again, and repeating until the lather is white, showing that the brush is clean. To speed it up, you can rub and then squeeze the soapy bristles between your thumb and index finger.

Figs. 80 and 81. There is a special container for cleaning brushes— double-bottomed jar. The first bottom is full of holes. When you fill the container with turpentine, the paint from the brushes drips to the second bottom. This way, the next set of brushes can be washed with fairly clean turpentine.

80

81

Palette knives, maulsticks

A palette knife is a type of wooden-handled knife with a rounded-off, flexible steel blade but with no cutting edge. Palette knives are usually trowel-shaped. They are mostly used for scraping paint off a painted area, or for cleaning the palette or painting. Painting with a palette knife requires special dexterity—two or three spatulas are used instead of brushes.

A maulstick is a light stick of wood about 39 inches long, with a ball-shaped tip. You can use it to steady your hand when fine details or a very precise finish has to be applied and you can't rest your hand directly on the painting because it is still wet.

Maulsticks are rarely used these days.

Fig. 86. How to work with a maulstick: The tip should rest on a relatively unimportant area, the background, for example. It supports the painting hand when you need to paint an outline or very precise lines.

Fig. 82. Mixing and working with oil paints on the palette with a palette knife.

Fig. 83. Palette knife full of oil color, ready for use.

Fig. 84. Using a palette knife to paint.

Fig. 85. You can clean the palette knife with newspaper.

Fig. 87. From left to right, five palette knives and a maulstick.

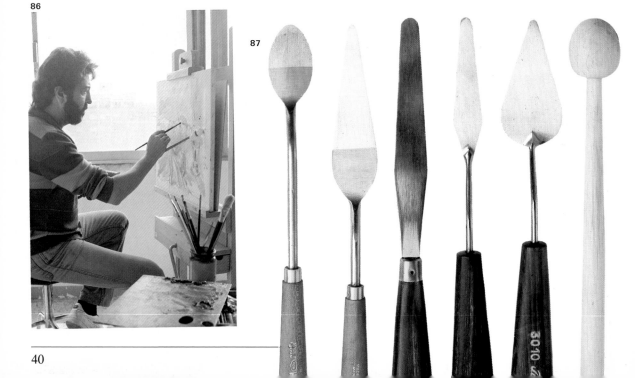

Solvents and dippers

Fig. 88. Rags: old cotton or linen rags are always very useful. Try them for wiping brushes, drying or cleaning the palette, or even rubbing out a section of your painting. If you use a charcoal draw-ing as a guide for your oil painting, you'll need an aerosol fixative for the charcoal.

Fig. 89. Double dipper and single dipper (attached to the palette).

Fig. 90. For oil painting you can use linseed oil, distilled turpentine, finishing lacquer, and a finishing protective lacquer.

The solvents most often used in oil painting are turpentine and linseed oil. Some artists use a mixture of the two, others (myself included) use turpentine alone. The more linseed oil you use, the longer your painting will take to dry, but the shinier it will be. By contrast, turpentine dries quickly, leaving a matt finish. In painting, it is important to remember the basic rule of "thick on thin." You should paint the first layer or two with practically no oil, diluting the paint with distilled turpentine, so that the next layer of paint applied to this surface will not crack as it would on a slightly damp surface.

You can buy special dippers to hold the solvents while you are painting. They are usually metal with a clip-on base that can be attached to the palette. Double or single dippers are obtainable, but when you are painting in the studio you may find a larger pot more useful.

Charcoal and an aerosol fixative may be necessary for the first stage, the composition of the picture.

88

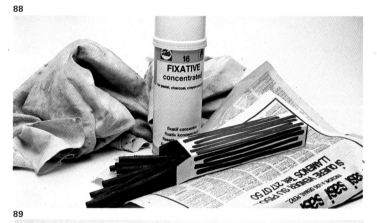

89

90

Oil colors

At this stage, it's a good idea to establish what oil colors you're going to use, how much you'll need, and which brands are considered the best.

Manufacturers of oil colors offer a very extensive color chart with more than seventy-five different colors. Most professionals think that just fourteen colors are enough. As to the amount of each color needed, oils usually come in three sizes (large, medium, and small); the medium size should be enough for all colors except titanium white. For white, a large tube is advisable, since white is the color you will use the most.

91

Fig. 91. Tubes of oil in different sizes. Titanium white is the color used most; a large tube is advisable.

Fig. 92. Here are different brands of oil tubes. The three tubes on the left are for the "student," the other three are for the "professional."

92

Special box for oil paints

A special box for your oil paints and mediums is not needed when you are working on still lifes. But it is part of an artist's equipment for outdoor painting, whether you prefer country landscapes, urban scenes, or seascapes. A portable oil painting kit can be used in the studio too, as a useful unit that the artist can use for picking up and putting down brushes, tubes, and paint rags.

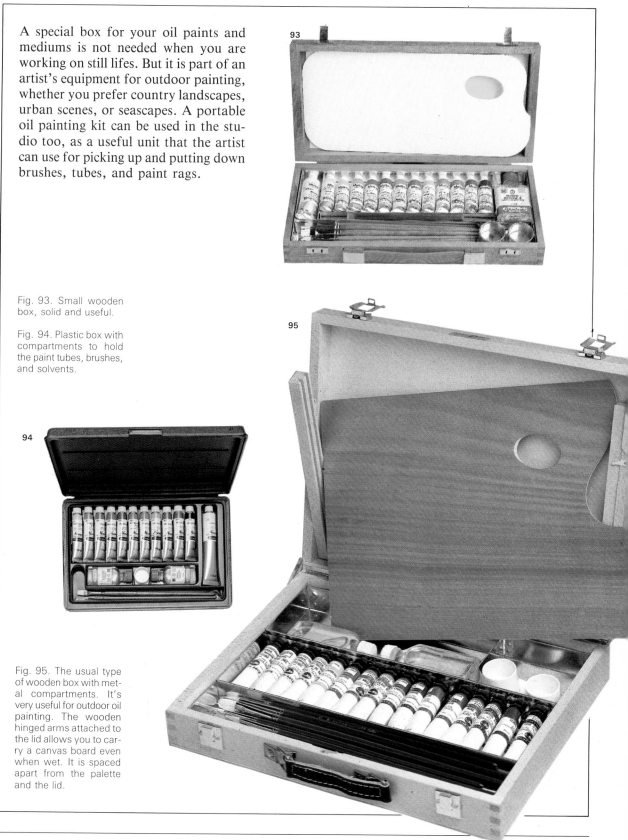

Fig. 93. Small wooden box, solid and useful.

Fig. 94. Plastic box with compartments to hold the paint tubes, brushes, and solvents.

Fig. 95. The usual type of wooden box with metal compartments. It's very useful for outdoor oil painting. The wooden hinged arms attached to the lid allows you to carry a canvas board even when wet. It is spaced apart from the palette and the lid.

Paul Cézanne developed the basic rule to structure any drawing: All shapes can be reduced to a geometric figure—a cone, a cylinder, a sphere. On the following pages, you are going to learn how to work with various objects and elements of a still life, such as the transparent quality of glass objects. This principle will help you draw many different shapes.

After mastering the structure of objects, you will be dealing with the distribution of the elements on the painting's surface. To create a unique and exciting distribution of elements, you must know how to apply two fundamental principles: perspective and proportion.

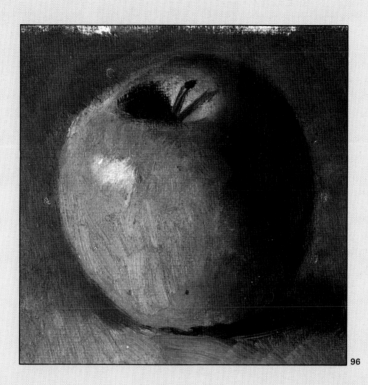

96

SHAPE
—AND—
VOLUME

Study of shapes

Even as a young man, Paul Cézanne was attacted to still lifes and the study of shapes and volume. Around 1860, he copied a detail from a still life by a Dutch painter that was exhibited in the museum of Aix-en-Provence. From the picture, Cézanne selected the part he felt would help him best study spherical volume: a dish of peaches (Fig. 97). In April 1904, two years before his death, Cézanne wrote to his friend Emile Bernard: "All forms in Nature fall into the cylinder, the sphere or the cube, everything in proper perspective." This approach, expressed earlier in other letters, at artists' gatherings, and in conversations with his friends, was applied by Cézanne in his later works and was used by many artists at the beginning of the twentieth century. From that geometric theory, Picasso developed cubism and it became a basic principle in drawing and painting.

Cézanne's theory is especially valid when it comes to examining the shapes of the objects that make up a still life. For example, it is evident that objects such as a table, a pile of books, and a tablecloth with a rectangular design are essentially cubes; an apple, a grape, an onion, and a cooking pot, are basically spheres; and a glass, a cup, and a bottle are cylinders.

Fig. 97. Paul Cézanne was attracted to the study of shapes since his youth. Around 1860, he copied this detail from a still life that allowed him to study volume better.

Square	Sphere	Circle and cylinder
Table	Various fruits and	Wineglass or tumbler
Book or books	vegetables:	Cup
Box or case	Apple	Bottle
Tablecloth	Peach	Casserole dish
Objects with no	Plum	Saucer
precise shape but	Melon	Ashtray
that fit into	Orange	Other pottery or china
the shape of a	Tomato	Objects
square or a cube,	Onion	Jug or vase
for example a	Potato	Pot
flower, a banana,	Head of garlic	Other containers
a bunch of grapes	Pitcher	
	Earthenware jar	

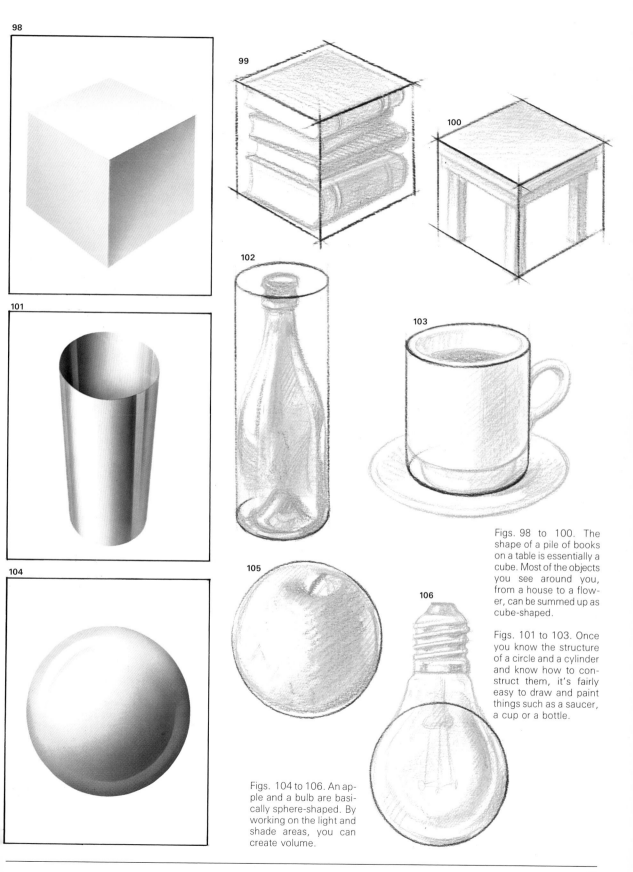

98

99

100

101

102

103

104

105

106

Figs. 98 to 100. The shape of a pile of books on a table is essentially a cube. Most of the objects you see around you, from a house to a flower, can be summed up as cube-shaped.

Figs. 101 to 103. Once you know the structure of a circle and a cylinder and know how to construct them, it's fairly easy to draw and paint things such as a saucer, a cup or a bottle.

Figs. 104 to 106. An apple and a bulb are basically sphere-shaped. By working on the light and shade areas, you can create volume.

Construction and perspective

The cube, the square, and the rectangle always present a problem of perspective. By knowing how to use perspective, the artist can represent the third dimension: depth. As you may know, there are basically two kinds of perspective, depending on whether the object is viewed from the front (parallel perspective) or in the three-quarters position (oblique perspective).

Parallel and oblique perspective can be mastered if you know how to apply the following three factors:

> **The horizon line**
> **The viewpoint**
> **The vanishing point(s)**

The *horizon line* is always at eye level; you'll find it by looking straight ahead.

The *viewpoint* lies on the horizon line, in the middle of the observer's angle of vision. The *vanishing point(s)* are determined by the oblique lines of the object that un into the distance, meeting at the horizon line. With parallel perspective, there is only one vanishing point: the viewpoint. With oblique, or two-point perspective, there are two vanishing points whatever the viewpoint.

In Fig. 112, you see that from a cube or a parallelepiped drawn in perspective, a cylinder can be created.

Fig. 107. When the outline of a cube is drawn with all parallel lines, including the lines that incline into the distance (lines A and B), the cube lacks perspective and therefore lacks depth.

Fig. 108. When all the lines in a cube are parallel, except for lines A and B, the cube is drawn in *parallel perspective*.

Fig. 109. When the lines of a cube form two separate sets of lines, each converging toward the horizon but not parallel to each other, the cube is drawn in *oblique perspective*.

107

108

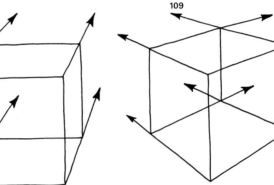

109

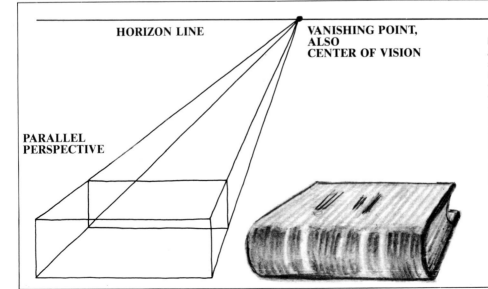

110

HORIZON LINE

VANISHING POINT,
ALSO
CENTER OF VISION

PARALLEL
PERSPECTIVE

Fig. 110. This is an example of parallel perspective with a horizon line and a combined vanishing point and viewpoint. It shows how the converging oblique lines of the object create an impression of depth. Using these lines properly, you should be able to draw a real object, for instance a book, correctly.

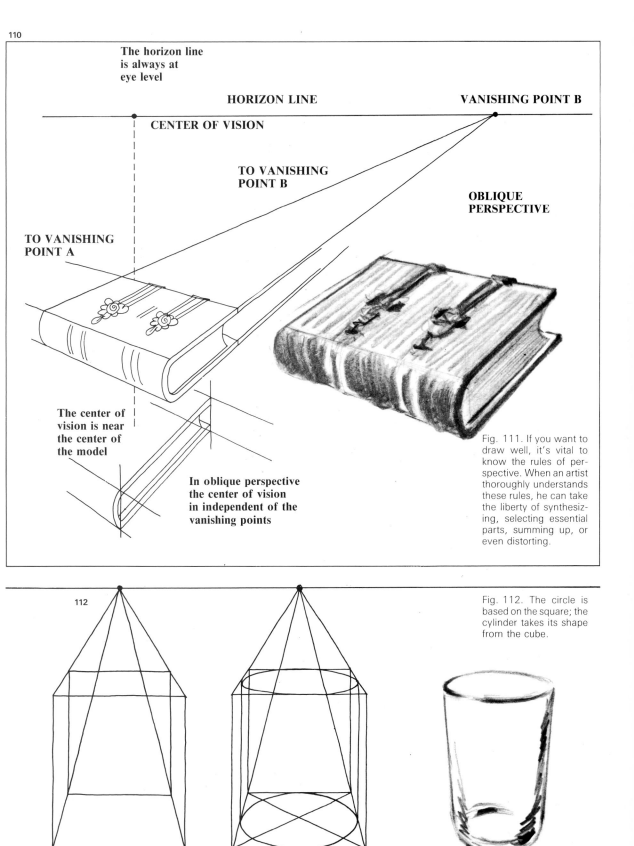

110

**The horizon line
is always at
eye level**

HORIZON LINE

VANISHING POINT B

CENTER OF VISION

**TO VANISHING
POINT B**

**OBLIQUE
PERSPECTIVE**

**TO VANISHING
POINT A**

**The center of
vision is near
the center of
the model**

**In oblique perspective
the center of vision
in independent of the
vanishing points**

Fig. 111. If you want to draw well, it's vital to know the rules of perspective. When an artist thoroughly understands these rules, he can take the liberty of synthesizing, selecting essential parts, summing up, or even distorting.

112

Fig. 112. The circle is based on the square; the cylinder takes its shape from the cube.

Structure

In modern painting, it is generally accepted that many artists alter and distort perspective, deliberately dispensing with horizon lines, viewpoints, and vanishing points. For example, an artist may portray the base of a bottle as a rectangle or construct a cube without representing depth. There is nothing wrong with this; in fact, it might even be good if you reach this stage through the need to create an individual style and personal form of expression. But I honestly believe that to arrive at what van Gogh called ''inaccuracies that are more real than the truth,'' you must first know how to draw a cube, a cylinder, and a circle correctly from memory—as easily as signing your name. You'll now see that it's not as easy as it sounds.

113

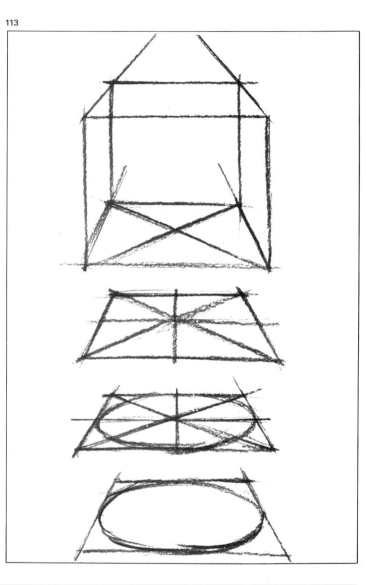

Fig. 113. Drawing from memory, without using a ruler or a square, try to do these sketches: a cube, a square, and a circle. Can you do it?

114

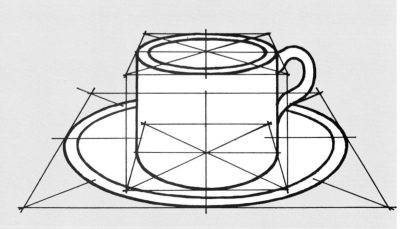

Fig. 114. If you can do Fig. 113, then you should be able to draw this structure, enclosing a cup and saucer. Obviously there's no need to draw such a complicated framework in order to paint a cup and saucer, but you should be aware that the framework exists and imagine it while reproducing the model. This way you'll avoid the typical mistakes of the amateur, which doesn't mean you lack a creative approach to art; they are merely errors stemming from a lack of technical expertise.

Common mistakes

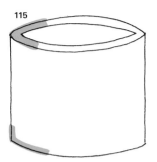

115

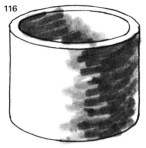

116

WRONG

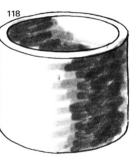

17

118

WRONG

RIGHT

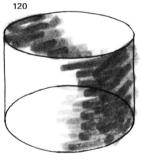

119

120

Figs. 115 and 116. In the base of this cylinder, you can see the common error of drawing a circle incorrectly. In the vertices of the base there's an angular shape, which is wrong.

Figs. 117 and 118. Another common mistake is trying to depict the thickness of a cylinder (left) by drawing two circles, one inside the other, without perspective.

Figs. 119 and 120. This figure illustrates the common mistake of drawing the upper circle of a cylinder with the same foreshortening as the lower circle. To see this more clearly, look at a column of circles (Fig. 121) viewed in perspective.

Fig. 121. This diagram shows a column of circles in perspective. Refer to this example when you are drawing cylinders.

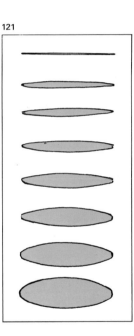

121

122

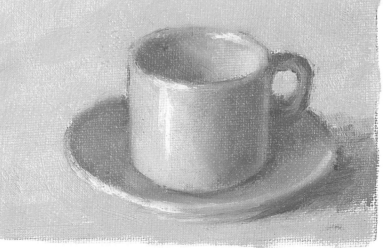

Fig. 122. Once you can correctly construct shapes with ease, you can proceed without aids, diagrams, or preliminary frameworks—indeed without drawing! Then you can try direct painting of cups and saucers, fruit, or any object, however complicated, concentrating only on volume and color. When you get to that stage, you can play around with shapes or ignore the rules of perspective, drawing and painting with complete freedom.

Dimensions and proportions

What size should you paint the model? In a still life, the size of your painted object should never be much larger than its actual size. Don't "blow up" the model too much, leaving scarcely any space around it. On the other hand, you shouldn't make an object in a still life so small that, when painted, it looks too small and the surrounding space too large.

All problems of good construction or *good drawing,* which is the same thing, can be solved by using three "magic formulas."

a) Compare various distances.

b) Look for reference points from which to project basic lines.

c) Imagine some lines in order to determine the position of some objects in relation to others.

123

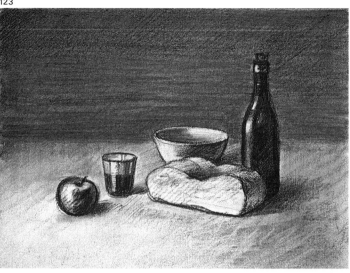

124 **125**

126

Fig. 123. For a still life, it is advisable to paint the actual size of the objects and to work on a canvas that is on the low end of the range of sizes (no. 12, 24″× 19⅝″, or smaller—see Fig. 60).

Fig. 124. "Blowing up" the model too much (or working on too small a canvas) is also a pitfall.

Fig. 125. Scaling down the model so that it looks lost in a vast area of canvas is another common mistake made by the amateur.

Fig. 126. Use two right-angled pieces of black cardboard placed one over the other; this way you can judge what the model will look like when framed. This will help you to determine the correct position and proportion of the objects within your painting.

127

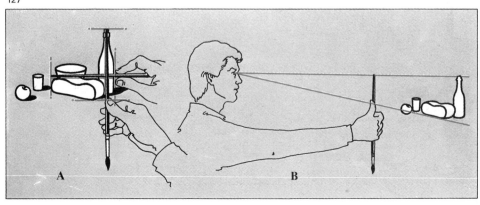

Fig. 127. A classic solution to the problem of dimensions and proportions is to measure the width or height of an object in a still life with another object (A). Here you see the way to use a pencil or brush to measure the height and width of the subject (B).

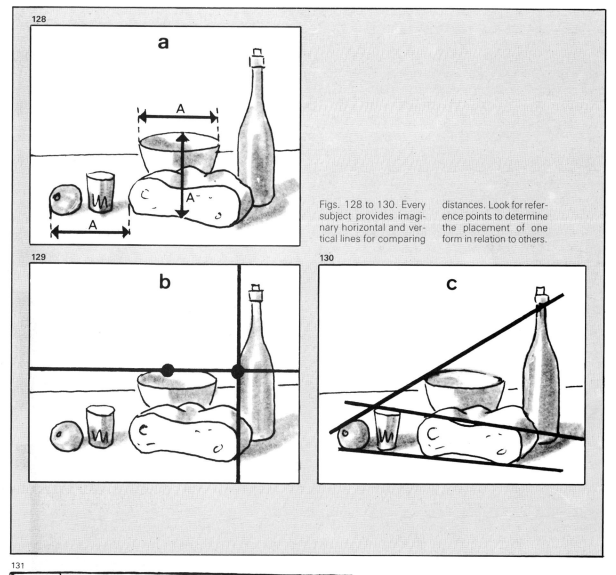

Figs. 128 to 130. Every subject provides imaginary horizontal and vertical lines for comparing distances. Look for reference points to determine the placement of one form in relation to others.

Fig. 131. Albrecht Dürer, the great sixteenth-century German artist, devised various kinds of apparatus for mechanical "drawing," which nowadays can be done with a pantograph. In fact, Dürer once invented a tool that was intended to copy plans on any scale—like a pantograph—but it never went beyond the drawing board.

Light, shadow, and tonal value

Fig. 132. To draw or paint the relief and volume of objects, you *must* bear in mind various factors.

Light outlines and colors objects. Shade defines the form and brings out the volume. To portray volume, you need to draw or paint tones in different intensities, or "values." You must compare and evaluate certain tones and look at the overall tonal value: This tone is lighter than that one; the tone here is darker than the one there; and so on. Values constitute a basic aspect in both drawing and painting. Sometimes it is possible to disregard the effects of light and shade, tonal values, atmosphere, and even volume. But obviously you must learn the basics before you can depart from them.

This oil painting of an apple illustrates the factors determining the volume of objects.

132

Light: lit sections where the color is the *actual* local color of the model.

Highlights: these are achieved by contrast. Remember that a light color becomes paler in proportion to the darkness of its surrounding color.

Deep Shadow: the darkest part of the shadow formed between the half-shadow and the reflected light.

Reflected Light: this appears immediately beyond the edge of the part in shadow. It is accentuated if a light-colored object is placed near the model.

Half-Shadow: the intermediate area between the illuminated part and the area in shadow. It is in chiaroscuro, which can be defined as "light in shade."

Shadow: the whole area of shadow that faces away from the illuminated part.

Cast Shadow: the shadow that appears on the surface on which the object is standing. It is usually darkest in the area nearest the object.

Figs. 133 and 134. The intensity of reflected light can be accentuated by a reflector screen placed near the subject—a blank white canvas will do. Use it with caution! Too much reflected light destroys volume and looks artificial. Ingres once said that to introduce exaggerated highlights in a shaded object debased the dignity of art.

133

134

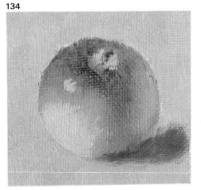

In order to depict volume, you must know how to work with light and shadow, together with *tonal values*. The latter involves seeing and understanding, observing and comparing the different gradations of tone that make the shape. There's no need for hundreds of color variations; it's possible to represent the whole range of tones in the model simply by using white, black, and five shades of gray.

Fig. 135. Here's an interesting exercise using an apple; paint in oils, using white and black only as I have done. You'll find that you don't need a huge number of tones—just a few can convey the volume.

135

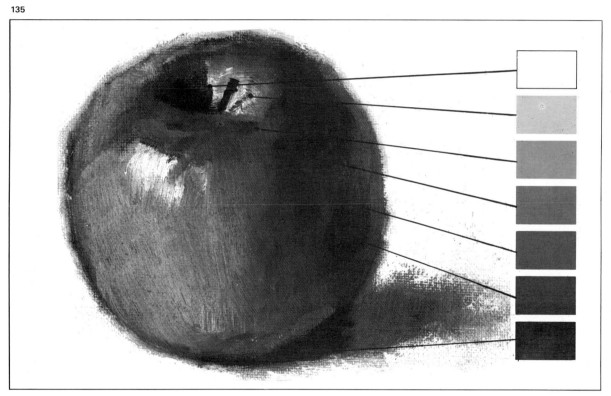

136

Fig. 136. A common way of picking out tones is to look at the model with squinted eyes. The model will blur, the small details will disappear, and the different tonal values will show up clearly, indicating the volume.

Contrast

Tonal values affect contrast; contrast decisively influences the impression of volume.

You can convey the feeling of space and depth between foreground and background by accentuating the contrasts in the objects nearest you while, at the same time, lessening the color or making the tones grayer in the more distant areas. On these pages, the basic rules of contrast and atmosphere are demonstrated through illustrations. Just remember that an illusion of space can also be created from blurred outlines, especially in the distant planes.

137

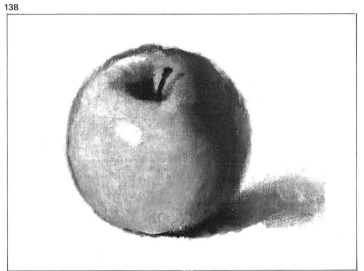

138

139

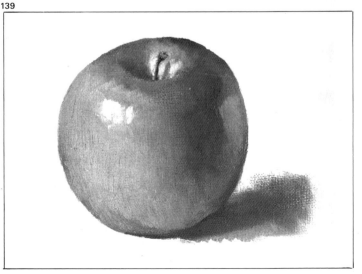

Fig. 137. BAD: Here you see a complete lack of contrast resulting from overemphasized tonal values. This presents a range of tones that is too dark and includes no light or medium grays. It's a common fault of the inexperienced painter who misuses black or dark colors.

Fig. 138. BAD: There is too much contrast and the tonal values are too light. The halftones and light grays are almost colorless; the white was misused, creating this light pastel appearance. What's more, it's accompanied by ''deep shadow'' which, though very dark, conveys scarcely any volume.

Fig. 139. BAD: This rigid, hard as a steel painting is not the style of a good painter. There is no atmosphere. The edges should be broken or blurred to create a vibration of light so the contours can recede to the back.

Atmosphere

140

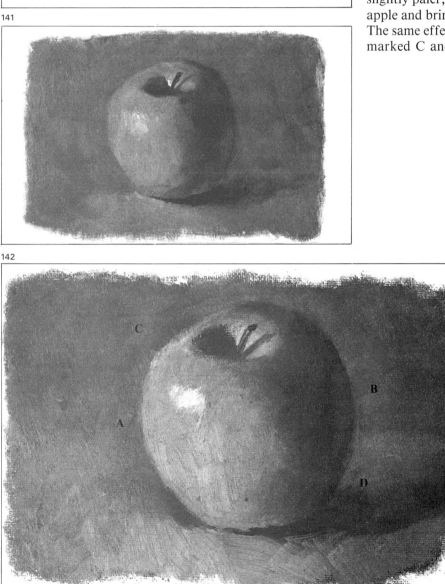

141

142

Let's put the apple on a surface such as it might appear in a still life. If the colors and tones of the surface are similar to those of the apple, the apple won't show up clearly and may look glued to the background, as if there were no space around the fruit (see Fig. 141).

How do you produce contrasts even if there are none? This is a trick of the trade. In Fig. 142, you can see that the surface near the lit part of the apple (A) has been made slightly darker, while near the part in shadow (B) it has been made slightly paler, showing the shape of the apple and bringing it "off" the surface. The same effects can be seen in the parts marked C and D.

Fig. 140. GOOD.: Compare this apple with the last one on the previous page. You'll see that the general blurring of outline and form produces a more realistic picture. This painting, technically good, also provides spontaneity.

Figs. 141 and 142. In the previous three figures, you have seen how to provide contrast to convey volume to an object. Now let's see the same apple on a background as it might appear in a still life. A contrast must be produced between the apple and the background (Fig. 142) to avoid "glued" look (Fig. 141).

A practical exercise

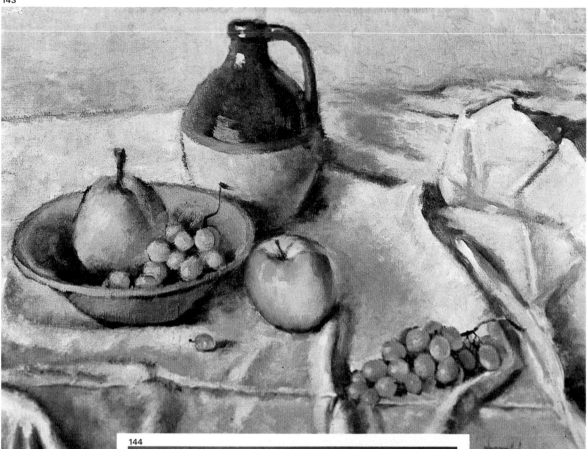

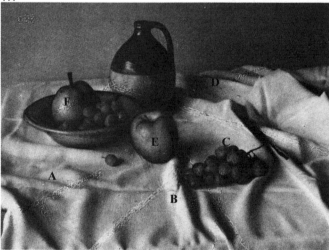

144

Figs. 143 and 144. Contrast, reflected light, deep shadow, highlights, shadow, and projected shadow... all the effects of light and shade are manifested in this little grape.

The effect of deep shadow is clear in this fold of the cloth; it adds volume to the cloth.

The more distant areas should be less sharp than the closer areas. Note here that the back line of the cloth is a vague, indistinct line.

In order to separate and distinguish shapes, you sometimes may need to emphasize an outline, as in these illuminated parts of the jar and the pear. This reflected light on the apple in shade did not exist in the model, but I created it in order to show where the apple ended and to separate it from the background.

The rendering of this bunch of grapes is a good example of reflected light.

I have painted this still life to demonstrate light and shade value, contrast, and atmosphere. Study the painting carefully.

145

A popular exercise in art schools, and one that can be done anywhere by any artist, is the drawing and painting of the folds of fabric, such as the cloth in the still life you've just seen. Cézanne, for instance, painted tablecloths, curtains, and fabric in nearly all his still lifes.

A carefully arranged piece of cloth, either in white or in a plain, light color, is an excellent subject in which to study the modeling—the effects of light and shade—of objects in general.

146

Fig. 145. As a young man learning his craft, the great German artist Albrecht Dürer made these pen and ink drawings of cushions, using the effects of light and shade to express volume.

Fig. 146. This exercise was done by the young Leonardo da Vinci: *Study of Drapery in a Seated Figure*.

Fig. 147. Now have a go at it yourself. Put a piece of fabric or a tablecloth over something on a table, or let it hang over the side to get unevenness and folds. Then begin painting, without making a drawing. This is a valuable exercise, as you will discover.

147

There's no subject matter that allows as much freedom of decision to the artist as the still life.

In most cases, the artist chooses the still life elements by just looking around the kitchen or the living room. He decides on a precise composition and chooses the subjects according to either their relationship to one another or their colors. In the following pages, you'll be dealing with the basic rules of composition, the structure of shapes to achieve contrast, atmosphere, color planning, and harmonization among warm, cool, and broken colors.

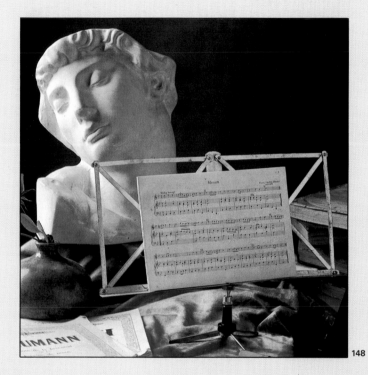

148

CHOOSING YOUR
SUBJECT
AND COMPOSITION

Affinities, subjects, elements

Paul Cézanne once wrote a letter to his son about the choice of subject: "The range is infinite; the same subject matter seen from different angles can provide such an interesting variety that I think I could work for months on end without moving from my place, just leaning a little to the right or left."
Cézanne was simply saying that a subject could be found anywhere or, as Renoir declared, that any object is suitable for painting: "Subjects? I can manage with one or two odds and ends of anything!"
All the same, it's certain that Cézanne and all the impressionists who painted still lifes *did* consider the theme beforehand, searching for things with some affinity and cogitating on a title that could sum up the painting's content. They tried to find related objects for elements of their still lifes.

149

150

Fig. 149. An affinity between components can express the subject and the artist's intention, as seen in this composition.

Fig. 150. In an attempt to express a particular idea or mood, the affinity of the elements of a still life may be relative, as in this picture of fruit with a jug, treated in a more modern idiom with simple lighting.

Figs. 151 and 152. (Right-hand page): *Still Life with Fruit* might be the title of the upper picture, while the still life below might be called *Music* or *Still Life with Flute*. The unity of content in the two works is further enhanced by the range of *warm* colors in the still life with fruit and by the range of *cool* colors in the still life concerned with music.

151

152

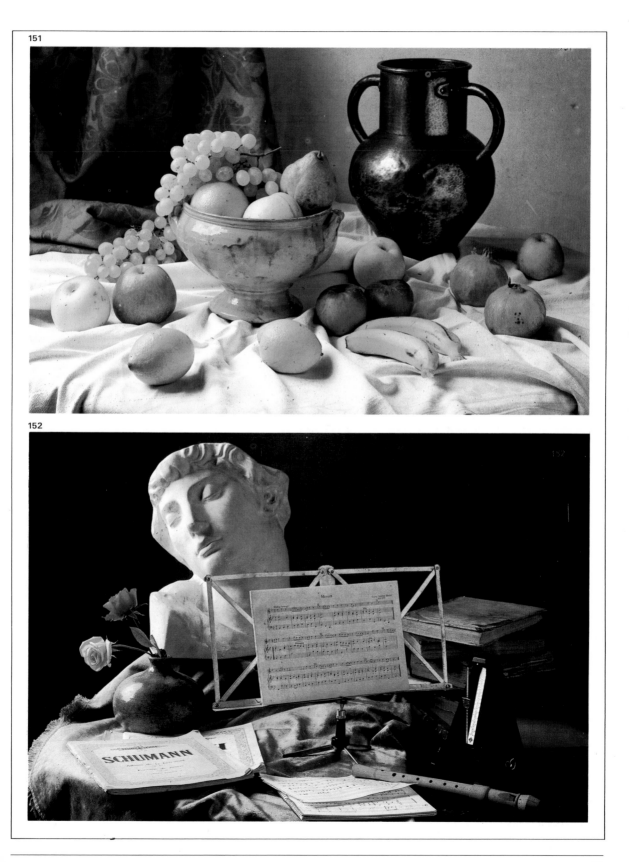

Organizing color

153

154

Fig. 153. (Above): Conventions and laws of art are never absolute. Artistic genius often lies in exceptional, unconventional works. In this still life, you see how a note of cool color is perfectly acceptable in a picture conceived entirely with warm colors—with red, ochre, and yellow dominant. Here, a flask containing blue liquid can be set without difficulty into the warm color harmony of the picture as a whole.

Fig. 154. In this photograph, you see a *range of broken tones* that comprise an unequal mixture of complementary colors, with the addition of a greater or lesser amount of white.

What is composition?

Composition is defined as the art of coordinating model, background, lighting, and color. "It means seeking balance and proportion, that is, beauty," wrote Jean Guitton. This might mean that beauty lies in unity. But according to René Huyghe, "There is a danger in unity; excessive unity leaves something to be desired; unity must be enriched by diversity." The same idea was expressed thousands of years ago by Plato, the Greek philosopher. *Composition is the skill of finding and representing unity within diversity.*

So it is, on one hand, a matter of arranging and coordinating model, background, lighting, and color to create a combination that does not turn out monotonous and dreary because of too much unity. On the other hand, the work should not be a muddle! It's not easy to strike the happy medium. As John Ruskin once said, "There are no rules for the art of composition; if there had been, Titian and Veronese would have been ordinary men."

155

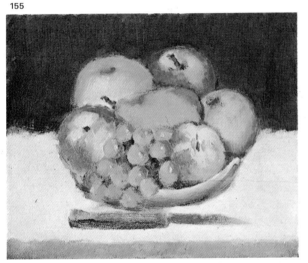

156

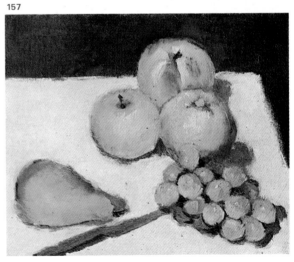

Fig. 155. BAD. There is too much unity and not enough originality here; the picture is monotonous and uninteresting. Notice in diagram 155 A how the emphasis on the horizon divides the picture in two, with the dish and the fruit forming a single block.

155A

Fig. 156. BAD. In this example, there is too much diversity: The objects are scattered; they attract attention separately and fail to make up a homogeneous group.

156A

157

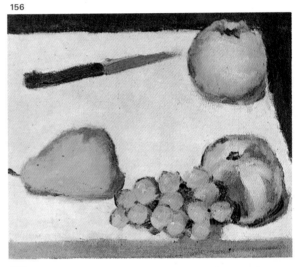

157A

Fig. 157. GOOD. This is a good example of unity within diversity. If you compare diagram 157 A with the others, you'll see the *unity* stemming from the arrangement of the elements as a whole. You'll also find *diversity* created by the positioning and lighting of the picture's different elements.

The rule of the golden section

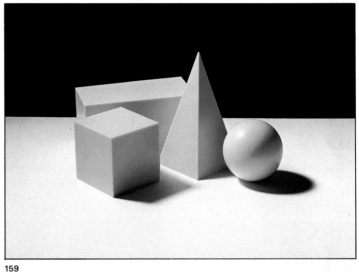

158

Suppose you have a blank canvas in front of you and want to begin your sketch. Should the main subject be placed in the center, toward the top, toward the bottom, toward the right, or toward the left? The answer to this question is given in an ancient precept that was handed down by the Roman architect Vitruvius, who wrote as follows: *To obtain an aesthetically pleasing unequal division of any given space, the lesser part must be in the same proportion to the greater part as the greater part is to the whole.*

To find this ideal division, multiply the width of the canvas by the factor 0.618 (the mathematical term for the rule of the golden section is the ratio 1:0.618; see Figs. 161 to 163). The result is the length of the width that is proportionate to the whole. Then do the same for the vertical length of the canvas. Note that the golden point (Fig. 162) is where the horizontal and vertical lines intersect. This is the precise point for the picture's center of interest. There are four golden points in every two-dimensional space (Fig. 163).

159

Fig. 158. It's not a good idea to arrange a still life in the middle of the space with the horizon dividing the picture in half.

Fig. 159. Nor is it wise to push the principal elements over to one side in order to obtain diversity through asymmetry.

Figs. 161 to 163. In order to obtain the *golden point,* you need to multiply the width and the length of the canvas by 0.618. There are four golden points to every two-dimensional space; you can place your main subject in either one of those points.

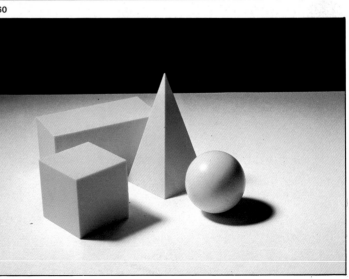

160

161 162

163

Fig. 160. Using the rule of the golden section, almost automatically gives you a better spatial arrangement.

Design

164

165

Fig. 164. Through experiments, Fischer found that, out of these three sets of basic shapes, the geometric set scored the highest among his subjects.

Fig. 165. This is an example of Rembrandt's formula for composition: A triangle or diagonal line dividing the picture into two equal parts, usually into a light and a dark area.

Figs. 166 and 167. These L-shaped compositions create greater diversity with their asymmetrical designs.

In every picture there is usually a distinct shape that dominates the composition. A composition depends on the way the main shapes are designed and patterned. One could say that the success of a shape is directly related to its symplicity. Experimental studies conducted by Fischer have demonstrated that, of three sets of different shapes (abstract, natural, and geometric, Fig. 164), his subjects tended to prefer the shapes that were geometric. Fischer attributed this to a nihilistic attitude ("maximum enjoyment with minimum effort"). René Huyghe arrived at the same conclusion when discussing the enormous predilection for geometric forms in art: "The more geometric the shape, the more enthusiastic the mind becomes, as a result of its ability to grasp the complexity of reality reduced to a basic shape." So try to work out a geometric design when you start thinking about the composition of your picture. Study the designs on this page.

166

167

Figs. 168 to 172. A rectangular or vertical division of the picture by light and shade; an ellipse on a dark background; a pyramid; a L shape; a truncated cone, respectively, may also provide satisfactory formulas or patterns for a basic composition.

168 **169** **170** **171** **172**

A B C D E

Symmetry and asymmetry

You may already know that a symmetrical composition presents all the components of a picture on either side of a central point so that the two sides correspond to one another equally. It's clear that *symmetry is virtually synonymous with unity,* whereas *asymmetry,* or free and intuitive positioning, even when balanced, *is synonymous with diversity.* Most artists prefer asymmetrical composition—it's more dynamic and spontaneous and provides greater opportunity to express creativity. But bear in mind that there are many possibilities in both types of composition. Symmetry can work well when used rather rigidly for a naïve style of painting; it can also be used more flexibly—the artist can shift objects around to emphasize the overall unity and still allow the desired variety to emerge clearly.

173

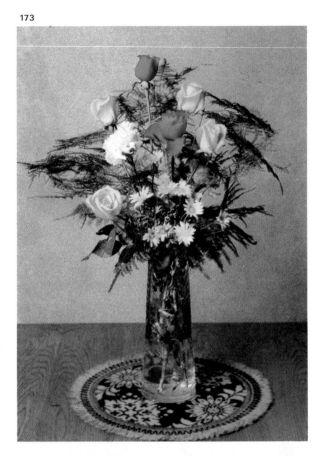

Fig. 173. It's difficult to avoid symmetry with a bunch of flowers in a vase, but you can place a flower or some other object at the foot of the vase to relieve the symmetry.

Fig. 174. Asymmetry is synonymous with variety and evokes more freedom of expression, hence innovation and experimentation. In this example, the arrangement looks fairly random; in fact, it took a great deal of thought and concentration.

174

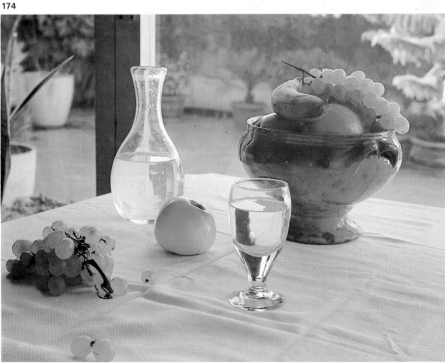

175

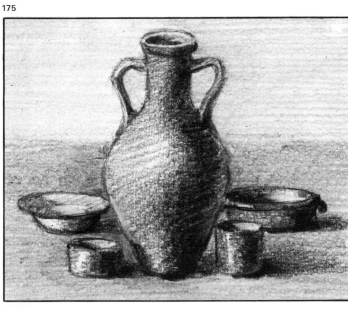

176

Figs. 175 and 176. By placing components evenly on either side of an imaginary central point in a painting you can give an impression of symmetry even when the elements are not particularly similar.

177

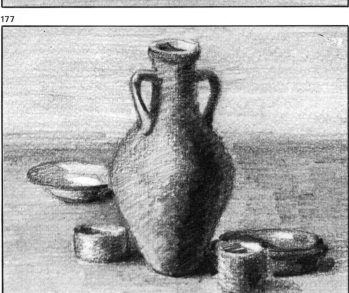

178

Figs. 177 and 178. It's easy enough to get away from an impression of complete symmetry by introducing diversity into an arrangement of objects.

179

Fig. 179. Symmetry and asymmetry depend on various factors. The former is usually accentuated by an eye-level view of the model with no perspective. But symmetry can be emphasized in a composition by the way similar shapes are positioned, such as the frontal view of a jars or mugs with handles showing.

Choose your lighting

When composing a still life painting you are not only able to choose and arrange your subject as you wish, but you are also able to choose the kind of lighting you want—its quality, type, and direction. **The type of lighting** can be either natural or artificial. In principle, it's easier to paint by natural light, with its greater quantity and consistency and its greater diffusion. Daylight is softer; it doesn't produce troublesome highlights and generally provides a better quality. It also shows the authentic colors of objects. Artificial light produces a slightly orange tint but the disadvantage is relative, since, apart from the fact that it may yield a stupendous range of colors (remember the case of Picasso painting by the gaslight that produced his "blue" period), the artist can easily modify

or correct this tendency. One of the greatest advantages of artificial light is that you can create special effects.
The quality of light may be described as diffused or direct. Daylight falling upon a model indoors will give a diffused light, unless the sun is shining directly on the model. If the sun *is* shining directly on the model, it's not a good idea to paint at all, because there will be excessive contrast. Artificial light always gives direct lighting, which is usually harder, diminishing the effects of light and shade and emphasizing the volume of the model. However, this effect may be useful when painting in a particular style. Finally, **the direction of the light** is another important factor to the artist. Frontal lighting is essentially a colorist's lighting —lighting appropriate for paint-

180

181

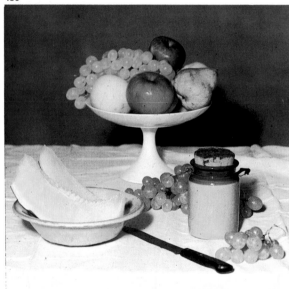

Fig. 180. *Artificial frontal lighting:* This is very much a lighting used by colorists. The fauvists used this lighting because they thought that color alone was enough to express form and outline, and that shadow and volume were unnecessary. Many of the Postimpressionists, including van Gogh, Gauguin, Vlaminck, and Matisse used this technique. Many artists use this type of lighting.

Fig. 181. *Artificial lighting from behind the model:* Here, a dramatic effect is heightened by the *quality* of the artificial light, which produces an extraordinary degree of contrast. A natural light from this direction will give a soft, intimate effect that is very suitable for painting still lifes.

ing rather than for drawing. By comparison, frontal-lateral lighting goes well with careful, descriptive work— it makes shape and volume absolutely clear. Light from behind the model, backlighting, conveys better than any other light an atmosphere of delicate intimacy or passionate lyricism, depending on the lightness or darkness of the background. So choose your lighting carefully, bearing in mind the different effects I have discussed and illustrated here. Remember that different kinds of lighting have very different effects on a finished painting.

182

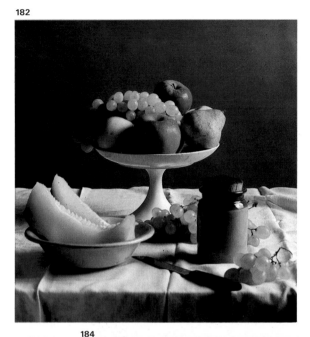

183

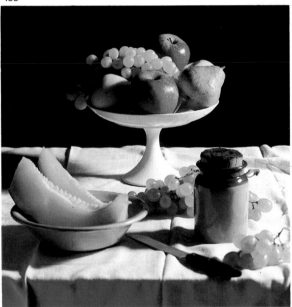

184

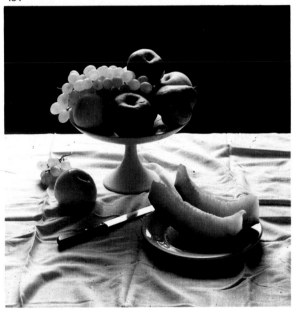

Fig. 182. *Natural lateral lighting:* With this type of lighting, you can convey shape through the effects of light and shade. This example shows the effect of diffused light from a window—natural light. You'll notice that the outlines of projected shadows are imprecise, for example, on the tablecloth. This is a classic kind of lighting.

Fig. 183. *Artificial lateral lighting:* In this example, there is great contrast. Areas in light are brighter; shadows are denser and much shorter; highlights are stronger (note the brightness reflected on the fruit bowl). The artist can correct these effects or interpret them in a different way.

Fig. 184. *Artificial lighting from behind the model, using a reflector screen:* This still life is illuminated by a table lamp, the same lighting as in Fig. 181 but with the addition of a reflector screen (which could be substituted with a blank white canvas, a no. 20 stretcher, placed in front of the model and oppo-site the lighting). This produces an overall reflection and softens the excessive contrast you see in Fig. 181.

Creating different planes

If the components of a still life—and this applies to any subject—are scattered all over the place, you will get too much diversity. As you may know, this can be corrected by grouping the picture's components and setting them in different planes. This will help emphasize the feeling of depth. Putting one piece of fruit in front of another, with a jug behind it, establishes the existence of a foreground, a middle ground, and a background. The illustrations on this page demonstrate some vital points on how to achieve depth—the "third dimension" in a still life.

Fig. 185. Imagine that these shapes are components of a still life. You will notice that when they are set one beside the other, there is no feeling of depth.

Fig. 186. By grouping these components, you can concentrate the interest and create a focal point.

Figs. 187 and 188. If each component is placed very carefully (with some objects set in front of others, trying for *unity* at the same time as *diversity*), you'll get a clear impression of front and back, creating the illusion of depth.

185

186

187

188
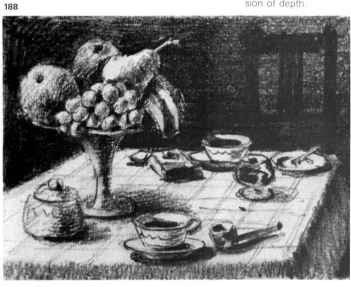

189
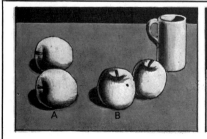

190
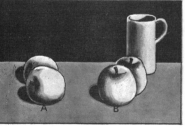

191
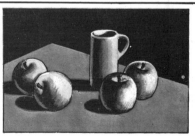

Fig. 189. Every artist has his own method of creating planes—there are no set rules. In this example, the placement of apples A and B does not give enough impression of depth.

Fig. 190. Apples A and B in the foreground have apples placed directly behind them, in the second plane; the positioning of the jug in the background illustrates the same fault. Because this type of grouping divides the objects into two sets, there is no unity in the composition.

Fig. 191. This example shows a perfect treatment of depth—just right. The lateral lighting emphasizes the shadow of the jug, which unites with the other components to make a single cluster.

From theory to practice

Louis le Bail, a young French painter at the beginning of this century, was lucky enough to be with Cézanne when he was composing a still life. From that experience, le Bail commented: "He went to and fro between table and easel, continually looking from easel to model; he worked a little on the folds in the tablecloth, on which he placed three or four peaches and a jug decorated with flowers. Deep in thought, he returned to the easel, took a careful look, cast down his eyes for a moment and looked again; he returned to the model to add a few green pears, to study the green on the pears and the red of the peaches; he made the complementary colors vivid and used a few boxes to raise the level. What a time it took to achieve that higher level! He worked meticulously, subjecting each new arrangement to patient scrutiny."

Then, according to Cézanne's friend Emile Bernard, "He would contemplate the model for a long time, see it in his own way and create from this vision something permanent." But that I'll discuss later in *interpreting the model*. Don't forget le Bail's description of Cézanne at work; his still lifes were arranged with dedication, by testing, looking, trying again and again until he felt satisfied.

Figs. 192 and 193. It is important to spend time preparing the arrangement of your still life before you paint. With a subject such as the one in Fig. 192, you may after experimenting end up with a model like the one in Fig. 193.

192

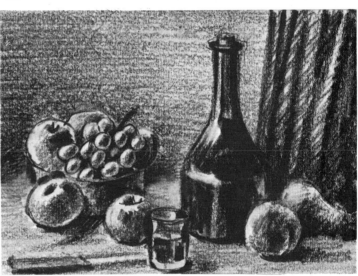
193

194

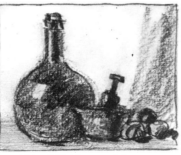
195

196

Figs. 194 to 196. It's a good idea to prepare two right-angled pieces of black cardboard to use as a frame so that you can study the compositon of your picture (Fig. 194). It is also useful to draw one or two preliminary sketches in charcoal, red chalk, or very soft lead pencil (4 or 6B), working in a size no larger than 4¾" × 6¾" (12 × 17 cm). When you are drawing try to work out the position and proportion of the components of your still life in relation to your surface, as well as studying the colors of the background components and the type of lighting.

Now you'll learn about the "workshop" of oil painting. This is a good term when dealing with still lifes, since it is necessary to use all kinds of techniques and manual abilities: the proper distance and viewpoint, the arrangement of the background, the direction of the strokes, the right painting technique, and the use of gradation. By reading the following pages carefully, you will learn the secrets of this craft, which will take you halfway to success. All the rest is a matter of practice.

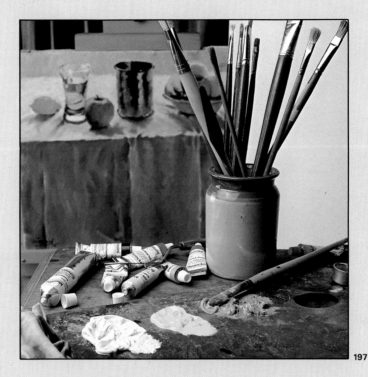

197

OIL PAINTING:
——CRAFT——
AND TECHNIQUE

Professional tips

198

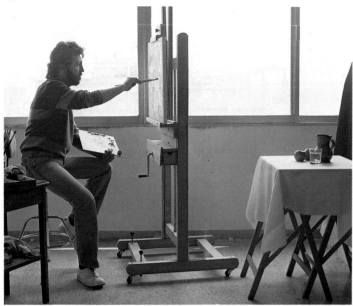

How far should I be from the model?
At most 5 to 6½ feet (1½ to 2 m). Some say that the model must be at least 9¾ to 13 feet (3 to 4 m), but I disagree with that. From 13 feet away, a bunch of grapes becomes a splash of color; you need to be at least 6½ feet closer to appreciate all the different shapes, the chiaroscuro, and the colors.

Maximum distance: 6½ feet (2 meters). What about the artist's viewpoint? Should the model be seen from a high position, a low position, or somewhere in between? It's common to take a viewpoint with a 45-degree angle of vision, using the other objects to emphasize the viewpoint.

Fig. 198. Distance from the model should be about 5 to 6½ feet (1½ to 2 m). The angle of vision should be about 45 degrees.

Figs. 199 and 200. If you paint looking down at the model, and too close, you'll get a rather peculiar and unsuitable perspective.

199

200

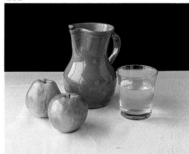

205

201

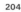

202

Figs. 201 and 202. If your painting stool is about 27½ inches (70 cm) high, and you are sitting about 5 to 6½ feet (1½ to 2 m) from the model, with your angle of vision at about 45 degrees, the perspective should be correct for a still life.

Figs. 203 and 204. If you paint from a position almost eye level with the model, you'll get a rather unusual frontal view.

203

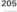

204

Care of palette and brushes. They should be cleaned regularly; dip and rub your brushes clean with turpentine at least three or four times.

206

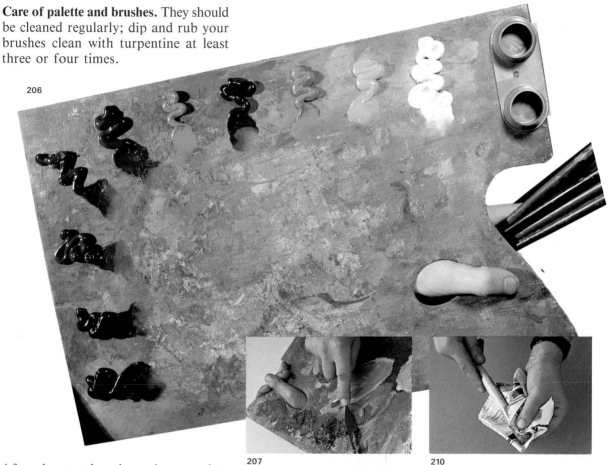

After about an hour's work on a painting, you may well be short of space on your palette for mixing new colors. Let's say you want to mix a special pink with a bluish tinge. This is where the crunch comes. If you are inexperienced, you may make the pink from some left-over white (which won't be very clean), using an earlier mixture of carmine and cobalt blue and perhaps something else you can't quite remember—ending up with a gray-tinged pink. If you know better, you'll realize that the time has come to stop, clean the palette, renew some of the colors, clean the brushes, and start again from scratch.

207

210

208

211

209

212

Fig. 205 (far left, p. 76). The American artist Ken Davies often chooses a low position, level with the model. This still life, painted meticulously in the *trompe l'oeil* style, is characteristic.

Fig. 206. This shows a typical arrangement of colors on a palette.

Fig. 207. Clean the palette with a palette knife as if you were using a trowel.

Fig. 208. Then clean the palette knife with newspaper.

Fig. 209. Now rub the palette, first with a few sheets of newspaper and then with a rag and turpentine.

Fig. 210. Clean the brushes, wiping off the paint with newspaper.

Fig. 211. Then dip them into turpentine.

Fig. 212. Finally, use a rag to squeeze the brushes clean, one at a time.

Draw first, or paint right away?

Now you're all set: a still life carefully arranged, a palette full of color, and a blank canvas that is "empty, defending its whiteness," as the poet Stéphane Mallarmé described the difficulty of beginning a work. And you wonder whether to begin by drawing with pencil or whether to paint right away. This is an age-old problem that has been debated for centuries. Way back in the 1500s, the Florentine Vasari wrote about a visit to Venice, describing Titian's approach: "He used colors immediately, without making preparatory drawings; he said that this was the right and proper way." At about the same time, Michelangelo, who always began by drawing, slyly remarked to Vasari: "What a pity that in Venice they don't begin by learning to draw correctly."

It seems that there are two completely different techniques. There are artists sometimes labeled as "colorists," who paint very few shadows; they use frontal or diffused lighting which helps them to see the whole subject as patches of color. This style has been used by van Gogh, Matisse, Bernard, and so on—they started from scratch with paint. Then there are painters who are loosely labeled as "valuists," those who work chiaroscuro, such as Chardin, Corot, Manet, Nonell, Dalí, and others; these artists started on a picture by drawing. But it's not a good idea to categorize any painter. It is known that Picasso sometimes began with drawing and sometimes with painting. "To paint or to draw?" said Cézanne, "When you get color in all its rich variety, you'll get plenty of clear shapes as well." This is true.

213
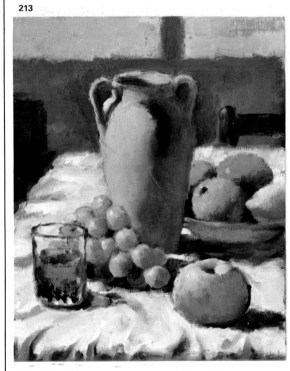

214
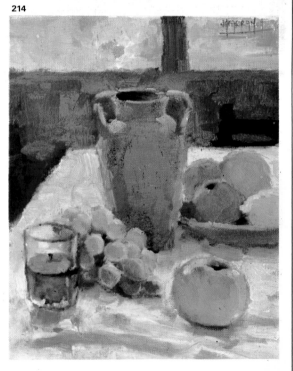

Fig. 213. You can treat any subject with either style, valuist or colorist—it all depends on your lighting. If you use lateral lighting, you'll be working in the "valuist" style; with frontal light in a "colorist" style. An artist who paints a still life with the full interplay of light and shade may start off by drawing.

Fig. 214. A "colorist" painter works in this style primarily because he considers it more abstract, more creative, and less academic. He also believes that color can express everything, without the aid of volume or modeling. As Bonnard once wrote: "Color on its own can express light, represent mass, and convey atmosphere."

Where should one begin?

215

216

The *law of simultaneous contrasts* tells us that a color looks paler or darker according to its surrounding color. Given this, it would be a mistake to begin by painting a small area or an isolated object on a blank canvas, since its value might become lighter or darker according to the surrounding color applied later.

So fill in the large empty spaces as soon as possible. In a still life, the large empty area is usually in the background.

217

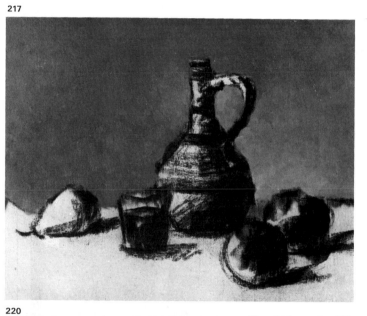

218

219

220

Figs. 215 and 216. Where do you begin? It's wise to get some color down as soon as you can. The canvas won't look so alarming and you'll eliminate false contrasts. In a still life, it's almost always best to start with the background.

Fig. 217. Even a single-colored background should present variety and richness of shades.

Fig. 218. BAD: This is an example of a completely uniform background.

Fig. 219. GOOD: The background should contain a variety of shades, even if it's only in one color; then, its true color will be enriched and be shown at its best.

Thick on thin

Fig. 220. A tried and tested rule to remember when applying the first layer of paint to a canvas is this: To prevent a painting from cracking as time goes by, you need to use more turpentine on the first layer. Paint as it comes from the tube is

thick—and becomes greasier if diluted with linseed oil. When paint is diluted with turpentine it becomes *thin*. Of course, a thick layer takes longer to dry than a thin layer. If you paint thin on thick by mistake, the top thin layer will dry more quickly than the thick layer beneath. When the latter dries, the top layer will contract and crack.

The direction of the brushstrokes

When oil painting with an easel, your canvas will be upright. So it may seem practical—and logical—to make vertical brushstrokes. But, when you think about it, you'll realize that this will depend on your subject. It doesn't make sense to use vertical strokes when painting a sea, a big bank of white clouds, or a cloth spread out on a table. Vertical strokes can provide a particular style, but the sea or a sunset should be done with horizontal strokes, clouds with circular strokes, and a tablecloth with horizontal or diagonal strokes. There are two norms or attitudes to keep in mind:

1. **Use brushstrokes that correspond to the "shape" of the objects you are painting.**

2. **In general, paint with diagonal brushstrokes.**

The former is the most common: A cylinder is painted with strokes curved to its shape; a field of grass is painted with vertical strokes; a melon is painted according to its form. If in doubt about the shape, or when painting generally, it's wise to paint diagonally.

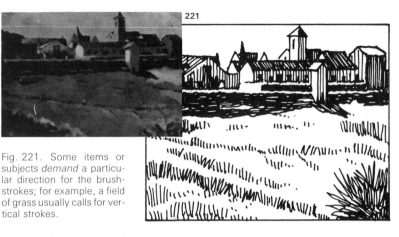

Fig. 221. Some items or subjects *demand* a particular direction for the brushstrokes; for example, a field of grass usually calls for vertical strokes.

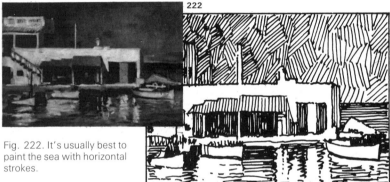

Fig. 222. It's usually best to paint the sea with horizontal strokes.

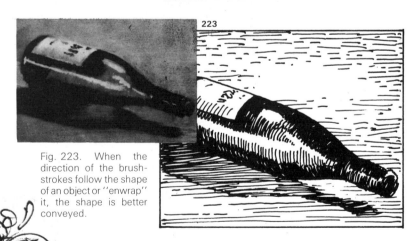

Fig. 223. When the direction of the brushstrokes follow the shape of an object or "enwrap" it, the shape is better conveyed.

Fig. 224. The best way to learn how to deal with shape is to make preliminary sketches in pen and ink, or crayon.

Synthesis

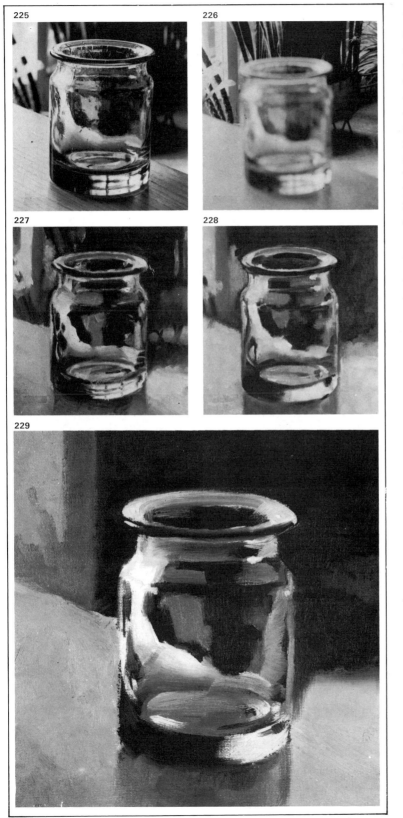

The ability to create synthesis in drawings or paintings is really a case of being able to see and draw or paint the most important parts of a subject, eliminating details and nonessentials. It is not easy and requires extensive knowledge of painting technique. It also means painting with freedom, spontaneity, elegance, and with understanding of the subject and your materials. Velázquez's work is a classic example of this: The eyes portrayed in the faces in his famous *Las Meninas* (Prado, Madrid) is a perfect example of synthesis; you can count the brushstrokes on the fingers of your hand.

Figs. 225 and 226. An easy way to help you see synthesis is to look at the model through half-closed eyes. These photographs show the same glass jar: Fig. 225 has full definition as seen with normal vision; and Fig. 226 is out of focus, as if you were seeing it through half-closed eyes. The latter example comes close to a synthesized image; it shows only the most important lines, the shape, the areas catching the light, and the highlights.

Figs. 227 to 229. These pictures illustrate the step-by-step development of a synthesized painting of the jar. Note the lack of detail and shapes of secondary importance. The final picture provides a combination of all you need to convey the jar's shape.

Painting *alla prima*

In Spanish, *a la prima;* in French, *au premier coup;* in Italian, *alla prima.* Painting *alla prima* means painting a picture in a single session. This is a frequently used method nowadays (in fact, there are rapid painting competitions), and it obviously requires a special technique.

Here are some important points to bear in mind when painting *alla prima:*

1. Decide on your range of colors—warm, cool, or gradated.

2. Draw your subject, but paint the largest areas right away.

3. Using the appropriate color, darken the parts of your subject that are in shadow with plenty of dark color.

4. Now you can use the *alla prima* method, but keep in mind these two basic principles.

A. Use all the creativity you possess.

B. Never change your mind; stick to your first impression.

There's an exercise to help you with this method later on, but here are some notes on the technique for painting *alla prima.*

Figs. 230 to 232. These illustrations show the process of painting light on dark. Fig. 230 shows the background and the parts in shade. The color was applied with very fluid paint immediately after the bunch of grapes had been drawn. Notice that there are color variations in the dark patch; its color is not uniform. In Fig. 231, you can begin to see the advantages of painting light on dark. Finally, in Fig. 232, the values of each grape have been synthesized by a simple touch of reflected light and a highlight.

230

231

232

Light on dark

Oil paint is opaque, so you can apply white over black, or ochre over burnt umber. When painting in the initial dark areas, make sure you dilute the dark colors with plenty of turpentine. By doing so, the dark areas will dry quickly and it will be easier for you to apply the light colors.

233

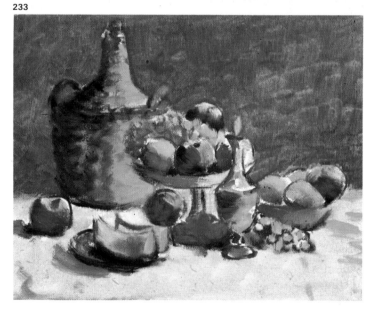

Fig. 233. When painting *alla prima* you may need a general tone in the first layer; use the dominant color of your subject. Look at the appearance of this layer in this *alla prima* treatment. Remember that the paint must be fluid to get a *thin* layer in order to dry fast.

How to paint on a wet surface

It is basically a matter of combining delicacy with a sure touch. A light hand is needed to avoid lifting the color beneath or, even worse, mixing the new color with the first. You need a sure touch because, when painting on a wet surface you can't have second thoughts; you paint with a chosen color; you construct in a chosen way, and what's done is done. If you want to go back, try again, retouch, repaint, or reconstruct, you'll be lost. Painting on a wet surface demands plenty of easily spreadable paint and a well-loaded brush. If the area is very large you'll just have to scrape off the paint with a palette knife and start again. Use a soft brush and diluted paint for details, such as the lines of a branch or a tree trunk. Either way, don't put pressure on the brush. Finally, when painting on a wet surface, it's essential that the brush be cleaned every time you use a new color, or it will mix with the previous still-wet layer of paint.

No man is perfect

I think the same applies to a picture. A "perfectly finished" picture is a lifeless picture. Perfect shaping, smoothing out,

234

235

236

Fig. 234. First apply a touch of paint on top of the wet part using no pressure, brushing it on gently.

Fig. 235. Next clean the brush with and old rag moistened with turpentine.

Fig. 236. Load up more paint on your brush and paint again, without rubbing; apply the paint cleanly; be careful not to mix one color with another.

Fig. 237. A smooth, overprecise, too perfect finish makes a work lifeless—wax fruit and plastic flowers.

Fig. 238. This "unpolished" rendering is more appealing. It's a quick, rather imprecise impression, but is fresh and spontaneous.

237

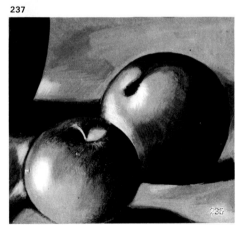

238

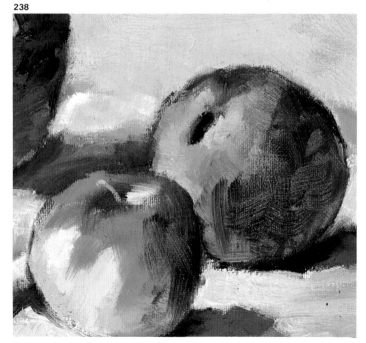

gradating shades of color, and overcorrecting can kill a work of art. Stop—don't finish it to perfection—you may finish it off! Fig. 238 is a thousand times more agreeable than Fig. 237.

To paint in any medium, an artist must learn and understand the basics of color. By mixing the primary colors—yellow, magenta, and blue—and sometimes including white, all the colors found in nature can be obtained. Once you become familiar with the primary, secondary, and complementary colors, you will be more comfortable experimenting with color in your paintings.

239

COMPOSITION
—AND—
MIXING COLORS

Mixing primary colors

There are three basic colors that cannot be made from any others: yellow, magenta, and blue, or cyan. They are called the *primary colors*, and by mixing them (sometimes with the addition of white), all the colors in nature can be obtained.

In oil painting, these three colors are called more precisely: 1. cadmium yellow medium; 2. deep rose or madder lake; 3. Prussian blue. As Fig. 241 shows, *primary colors* mixed in pairs produce three *secondary colors:* green, red, and blue-violet or dark blue.

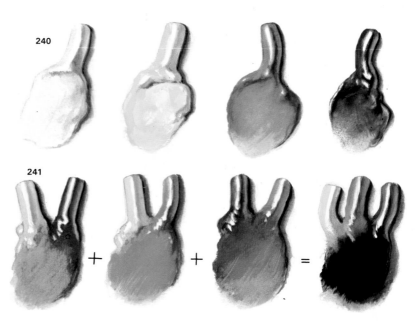

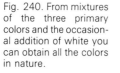

Fig. 240. From mixtures of the three primary colors and the occasional addition of white you can obtain all the colors in nature.

Fig. 241. The mixing in pairs of the primary colors provides the secondary colors. The three primary colors mixed together create black.

Fig. 242. A mixture of cadmium yellow medium and madder lake deep gives a third color, vermilion or vivid red, as well as a wide variety of pastel colors: pinks in warm and cool tones.

Fig. 243. This range of colors was produced with a mixture of cadmium yellow medium and Prussian blue, giving a variety of greens.

Fig. 244. Finally, by mixing Prussian blue and madder lake deep with white, a broad, rich range of blues, violets, and purples is obtained.

245

Fig. 245. This collection of colors was obtained with the use of the *three primary colors* only. Try it yourself! It will show you that all the colors in nature can be made by mixing the primaries plus white.

Figs. 246 to 248. Here we show the mixture for painting apples with cool, warm, and broken colors.

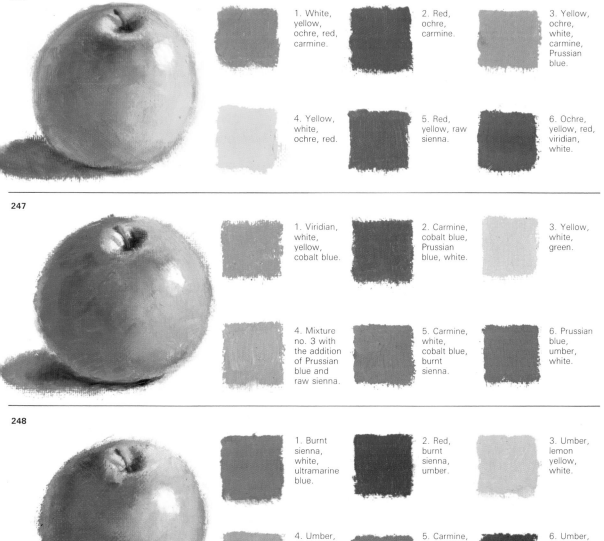

246

1. White, yellow, ochre, red, carmine.

2. Red, ochre, carmine.

3. Yellow, ochre, white, carmine, Prussian blue.

4. Yellow, white, ochre, red.

5. Red, yellow, raw sienna.

6. Ochre, yellow, red, viridian, white.

247

1. Viridian, white, yellow, cobalt blue.

2. Carmine, cobalt blue, Prussian blue, white.

3. Yellow, white, green.

4. Mixture no. 3 with the addition of Prussian blue and raw sienna.

5. Carmine, white, cobalt blue, burnt sienna.

6. Prussian blue, umber, white.

248

1. Burnt sienna, white, ultramarine blue.

2. Red, burnt sienna, umber.

3. Umber, lemon yellow, white.

4. Umber, white, yellow, red, cobalt blue, ochre.

5. Carmine, viridian, white, Prussian blue.

6. Umber, ultramarine blue, white.

Light colors and dark colors

Neutral, cool, and warm blacks

By mixing deep rose madder, Prussian blue, and burnt umber, you can make, according to proportion, a neutral black, a cool bluish black, or a warm black with a reddish tinge.

Adding black is only one way of darkening colors

When you want to darken or intensify a color, think about how nature works. In a rainbow there is no black (Fig. 250), only dark, intense colors.

If yellow is darkened with black alone, the result is a dirty greenish yellow; if it is darkened progressively with deep rose madder, blue, and black, a more natural range of intensities is produced (Fig. 251).

Similar results are obtained with the colors blue and magenta: The former (Fig. 252) has a tendency toward gray when darkened only with black; the latter (Fig. 253) loses its brilliance when darkened only with black.

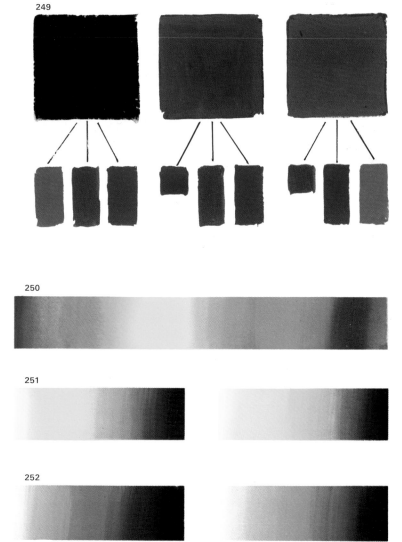

249

250

251

252

253

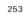

Fig. 249. With varying proportions of deep rose madder, Prussian blue, and burnt umber, you can create different shades of black.

Fig. 250. Here are the colors of the rainbow. Notice how the light colors gradate into dark, intense colors.

Figs. 251 to 253. These illustrations show how colors can be darkened with and without using black.

Figs. 254 A and B. In this demonstration, you will see the use and abuse of white and black. The tomatoes on the left (BAD) were painted with only red, white, and black. In the tomatoes on the right (GOOD), more colors were added: yellow, ochre, raw sienna, blue, green, and carmine, and just the right amount of white. Notice how a mixture of colors—without black—can create brilliant color intensities.

254 A B

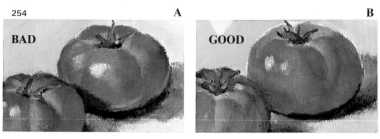

BAD GOOD

The color of shadows

There is blue in every shadow
Whatever the color of your subject, there's bound to be some blue in the shadow areas. This applies even if the model is entirely flooded in light and is white, as in this cube, the shadow of which is gray with a blue tinge.

The color of shadows and the complementary colors
The color of shadows contains not only blue, but also the object's complementary color. Complementary colors are the result of mixing primary and secondary colors.

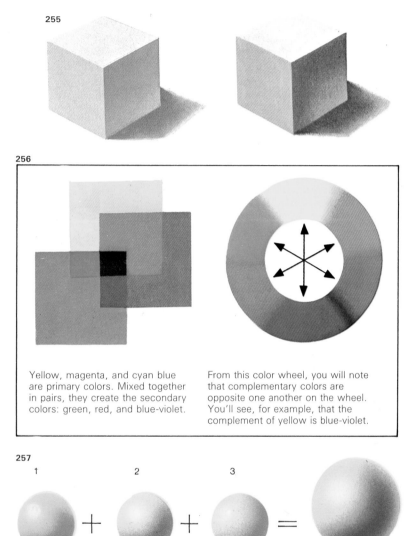

255

256

Yellow, magenta, and cyan blue are primary colors. Mixed together in pairs, they create the secondary colors: green, red, and blue-violet.

From this color wheel, you will note that complementary colors are opposite one another on the wheel. You'll see, for example, that the complement of yellow is blue-violet.

Figs. 255 and 256. The color of shadows always contains blue (Fig. 255) and the object's complementary color (Fig. 256).

Fig. 257. A formula for the color of shadows:
1. *The darkest color of the object* +
2. *The complementary color* +
3. *Blue = the color of the shadow.*

Fig. 258. The rule for painting shadows is almost infallible: The shadow color of this red tomato is composed of dark sienna, brilliant green, and luminous blue.

Fig. 259. The shadow color of a blue object is basically violet—the combination of cyan and magenta.

257
1 2 3

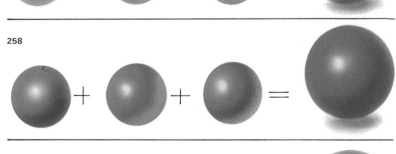

258

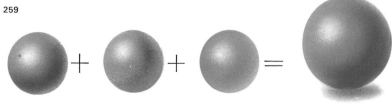

259

The warm range

Fig. 260. The warm color range is predominantly red.

Yellow, ochre, raw sienna, orange, red, carmine, burnt sienna, green... plus white: On this page, you see a range of warm colors.

See whether you can mix this set of colors.

1. White + cadmium yellow medium
2. White + yellow ochre
3. White + yellow ochre + cadmium red medium
4. Cadmium yellow + deep rose madder
5. White + cadmium red
6. White + deep rose madder
7. Raw sienna + cadmium red
8. Yellow ochre + burnt umber + a touch of cadmium green
9. White + yellow ochre + viridian + rose madder
10. Cadmium yellow + burnt umber
11. Yellow ochre + viridian + cadmium yellow + white
12. Rose madder + a touch of viridian

The cool range

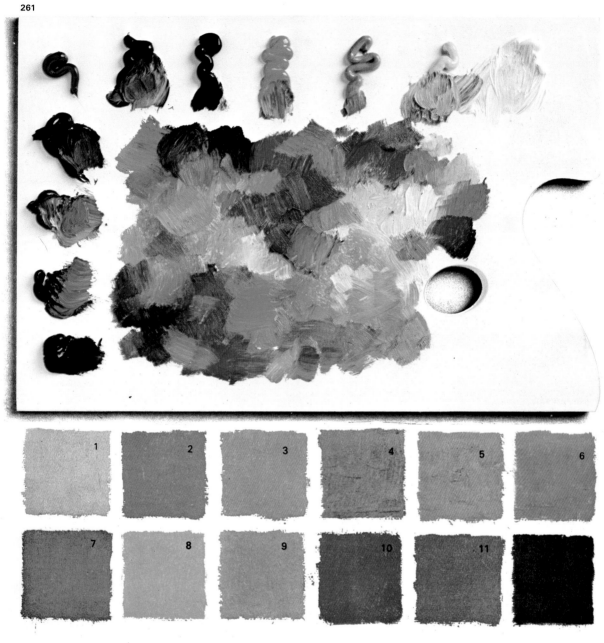

261

Light green, viridian, sky blue, violet... plus white: This page showsan example of a cool color range using basically greens, blues, and violets.

1. White + Prussian blue
2. White + light ultramarine blue
3. White + cobalt blue
4. White + Prussian blue + viridian
5. White + viridian + a touch of yellow ochre + a touch of cadmium yellow
6. Cadmium yellow + viridian
7. Cadmium yellow medium + Prussian blue
8. White + viridian
9. White + rose madder + light ultramarine blue
10. Prussian blue + white + rose madder
11. Yellow ochre + viridian + a touch of white
12. Prussian blue + viridian

Fig. 261. The cool color range is predominantly blue.

The range of broken tones

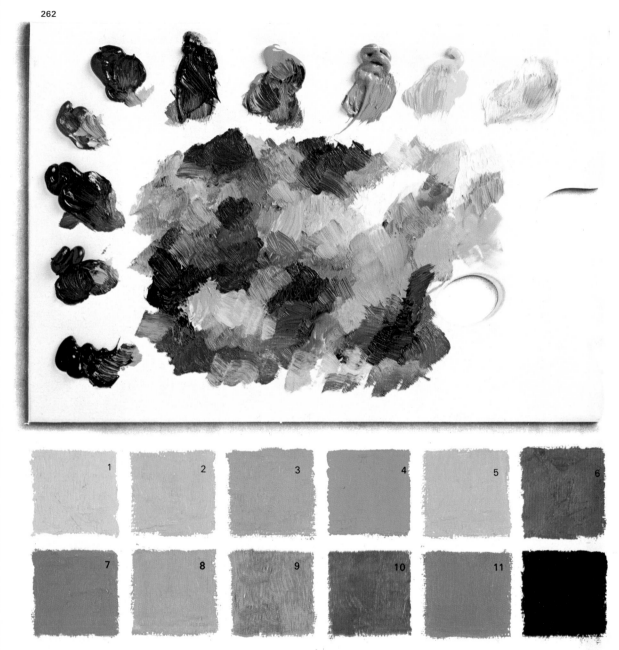

262

Fig. 262. The range of broken tones is predominantly gray but with enough color so you won't have a dull painting.

Mixture of complementary colors in unequal proportions... plus white. Here are some examples:

1. White + burnt umber + a tiny bit of Prussian blue
2. Same as no. 1, plus a touch of viridian
3. White + cobalt blue + cadmium red
4. White + yellow ochre + light ultramarine blue
5. Cadmium yellow + white + cobalt blue + a touch of cadmium red
6. White + Prussian blue + raw sienna + cadmium red
7. White + rose madder + cadmium red + Prussian blue
8. White + rose madder + viridian
9. White + burnt umber + viridian
10. Prussian blue + white + cadmium red
11. White + rose madder + ultramarine blue + a touch of burnt umber
12. Burnt umber + a touch of Prussian blue

263

264

265

Figs. 263 to 265. Three
paintings representative
of the three color ranges:
warm, cool, and broken.

In this part, I will begin with the teachings of the impressionist painter Paul Cézanne, who produced hundreds of still lifes. I will rely on his works and his techniques to demonstrate several basic norms that will help you begin your still life. Cézanne dealt with all the areas of his painting at one time. He was a master of interpretation; he resisted the urge to give a preconceived interpretation of the model and stuck to his original impression. What about colors? Cézanne combined color contrasts and achieved a rich range of tones. Please keep this in mind as you read the following pages.

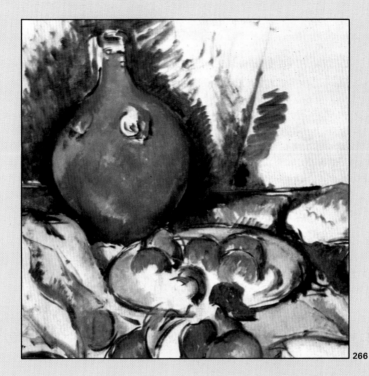

266

STILL LIFE
—IN—
PRACTICE

Cézanne, the great master

How Cézanne dealt with composition

Cézanne painted many still lifes with fruit. He used basic items, such as a white tablecloth and a plate or bowl of fruit, which he would put in the center of his composition. Quite frequently, he used a bottle, some pottery or china, and a pitcher, which he placed beside the fruit so that some of the items would form the picture's focal point. Sometimes other pieces of fruit and a fabric or a curtain was used as a backdrop.

The viewpoints for many of his still lifes tended to be quite high, and he rendered the shapes very freely and sometimes quite imprecisely. Cézanne took his time composing a still life. "An artist cannot evoke feelings as readily as a bird sings," he said.

Cézanne's way of painting

A farm worker who had watched both Pissarro and Cézanne at work once said, "When Mr. Pissarro paints, he pecks;

he does it in dabs with the paintbrush. Mr. Cézanne rubs and caresses; he paints with the brush flat."

Cézanne never lingered on just one area of a painting, but would paint here and there, not stopping to finish anything, leaving things incomplete, seeing and painting the picture as a whole.

This unfinished picture (Fig. 267) in the Tate Gallery is a good example of Cézanne's approach.

Cézanne did not draw a precise preliminary sketch: He simply put in a few rough lines and moved quickly on to color—just a few quick touches of paint thinned with turpentine, as in the plates and the tablecloth. In general, he painted from the outset with the actual required color and with the same thickness of paint used in the end. In the gray jar, for example, there are scarcely any second touches. Using a rapid painting technique, he painted the main elements

Figs. 266 and 267. Cézanne began his still lifes with practically no preliminary drawing. This unfinished painting, *Still Life with Pitcher*, is in the Tate Gallety in London.

267

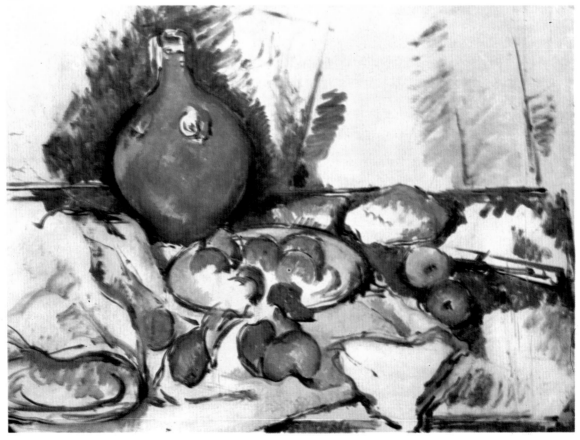

Fig. 268. *Still Life with Peaches and Pears.* Look carefully at the composition of this still life and compare it with the unfinished painting on the opposite page. You'll see that it adheres to Cézanne's formula for composing a still life: *White tablecloth on dark background,* with a plate or bowl of fruit in the center surrounded by other fruit, plus a jug, pot, or some other piece of pottery or china as the focal point.

early, avoiding errors by balancing and adjusting colors.

Pierre Bonnard once said that Cézanne was one of the few artists who could spend a whole evening painting from a model without being taken over by it.

Cézanne's skill: interpretation

Cézanne was one of the few impressionist painters who was able to look carefully at his model, receive a first impression of shape, color, contrast, light, and highlight, begin to paint, and be able to hang on to that first impression. As Pierre Bonnard once stated: "The presence of the model is a fatal temptation: the artist is in danger of being led astray by its closeness, which may drag him away from his initial conception."

Bonnard goes on to make his point, "Not long ago I tried to make a direct painting of some roses, with the model in front of me—but I let myself be carried away by details. I was soon out of

my depth: I realized I was getting nowhere, that I was lost and could never recapture my initial feelings, that first impression which had dazzled me so!" Bonnard continued, "It's vital that one discovers a way of fending off the influence of the model."

Cézanne was successful with his still lifes because he approached them in this way: Before he began to paint, he would gaze at the model for a long time and construct the picture in his mind. Then, when he SAW HIS PICTURE in his mind, he began to paint with what the English painter and writer John Berger described as "that heroic self-discipline," that extraordinary capacity for looking at his picture and watching its development just as critically and objectively as he studied his model. Summing up, John Berger wrote: "He makes it look easy. Easy indeed! About as easy as walking on water."

268

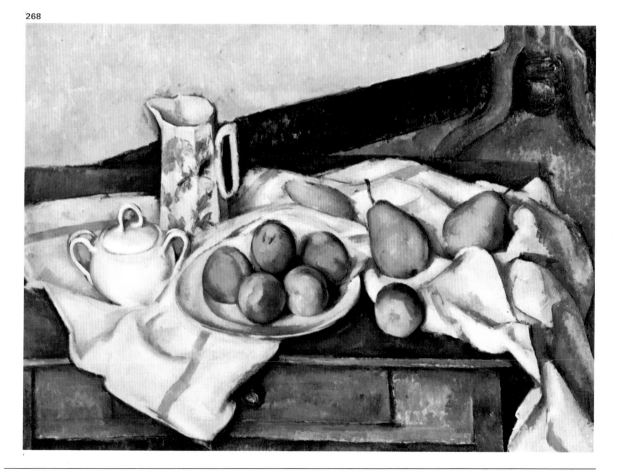

Step-by-step painting no. 1

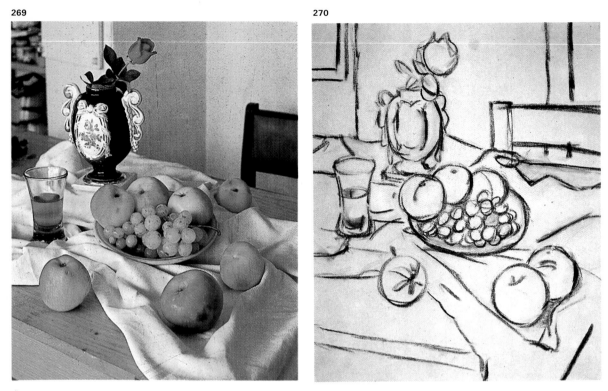

269 270

Now let's actually paint some still lifes with oils. The exercises that follow are based on three still lifes painted especially for this book. In each case there is an illustrated step-by-step guide to the work, from the preliminary drawing right through to the completed picture. The first painting is a classical theme and, to some extent, reminiscent of Cézanne's work. The second still life was painted using artificial light; it includes notes on dealing with the problems of painting glass. The third still life was carried out using the speed-painting technique and painted in a single session, in just over three hours.

Preliminary drawing (Fig. 270)
This charcoal sketch indicates the shape and position of each component. If you compare it with the photograph of the model, you'll notice two significant changes: The apple in the foreground, on the bare table, has changed in shape and position; it's a different apple. The peach by the chair in the background has vanished. Actually, my original arrangement is reflected in the sketch, I thought

I could improve on it by changing the apple in the foreground and adding a peach in the background.

Study of light and shade (Fig. 271)
There is more detail in this sketch than the first one—the structure is definitely established now. The various sections of volume have been included and you can see the overall balance of light and shade. When the sketch was completed, a spray fixative was applied to fix the charcoal before I began painting.

First step
The picture's development at the end of the first step can be seen better in Fig. 277 on page 100, but it's interesting to look at the beginning of the first step. I began by painting in the masses in the back, the gray parts of the tablecloth and the dark sienna of the table. By doing this, I got rid of the large empty spaces, making it easier to adjust the color of the fruits.

Figs. 269 to 272. Photograph of the model and three initial steps in this exercise of painting a still life.

Figs. 273 to 275. Painting a rose is no more difficult than painting an apple or a bunch of grapes. It's a good idea to draw in the shape of the flower first, very carefully.

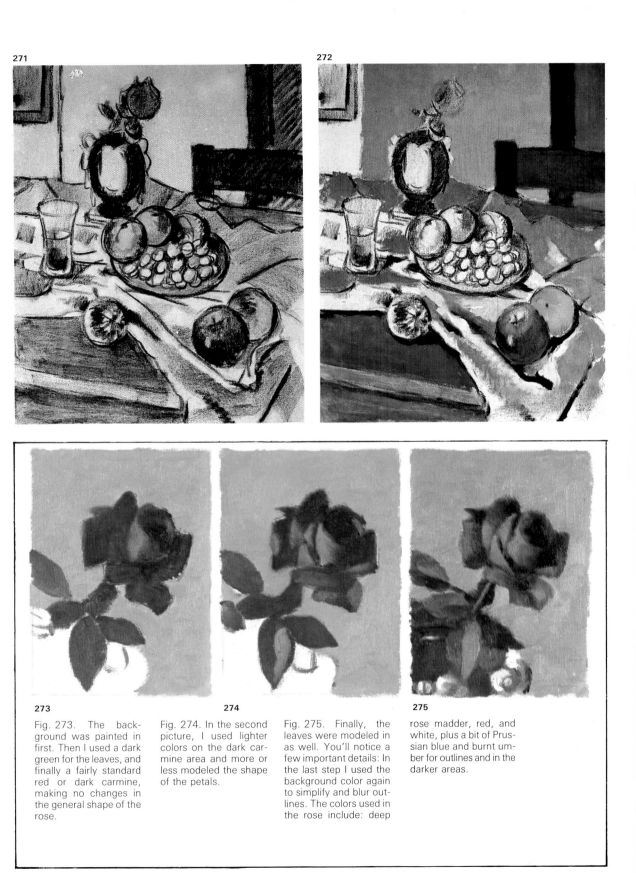

271

272

273

Fig. 273. The background was painted in first. Then I used a dark green for the leaves, and finally a fairly standard red or dark carmine, making no changes in the general shape of the rose.

274

Fig. 274. In the second picture, I used lighter colors on the dark carmine area and more or less modeled the shape of the petals.

Fig. 275. Finally, the leaves were modeled in as well. You'll notice a few important details: In the last step I used the background color again to simplify and blur outlines. The colors used in the rose include: deep

275

rose madder, red, and white, plus a bit of Prussian blue and burnt umber for outlines and in the darker areas.

Step-by-step painting no. 1

276

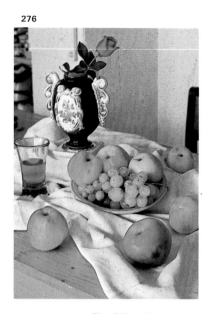

277

278

Fig. 276. Here is a reduced photograph of the model, to help you follow this step-by-step process.

Fig. 277. The state of the still life after the first stage of general coloring.

Fig. 278. In this step, color adjustments were made in different areas and elements of the still life.

End of first step: general coloring

The picture in Fig. 277 shows the state of the painting after the first stage of coloring, after all the components had been filled in with washes of paint. I'm still following my original model with no peach in the back and with a different apple in the foreground. Up to this point, there's been no attempt to get any clearly defined shapes, so changes can still be made. For example, I started the rose off as a bud, but I painted it in as an open rose. I also changed its leaves, as well as altered the arrangement of the grapes and the pieces of fruit in the bowl. The shapes of the fruit will be altered later. This doesn't mean that everything you see here is temporary! You'll find that many components of this still life will be kept just as they are, for example, the background: the chair, the picture behind it and the basic lines of the tablecloth.

279

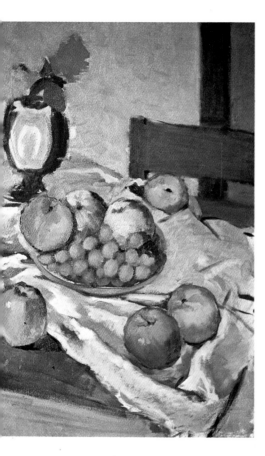 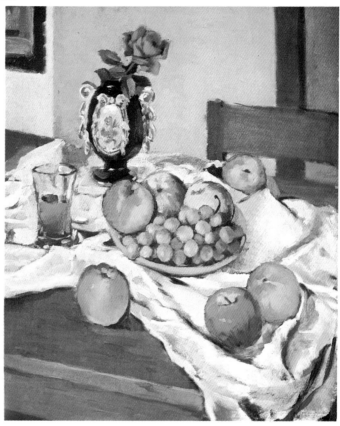

Second step: adjusting shape and color
At last I've worked out a final version: I've changed the apple in the foreground, added a peach in the background and replaced two of the peaches in the dish with two apples. The idea is to try to get greater variety in shape and, especially, in color. Some parts of the picture are now there for good; for instance, the peach in the background and the two apples in the dish, and to some extent, the pieces of fruit in the foreground. But the bunch of grapes will be changed and painted again, as you'll see in Fig. 279. Perhaps the best advice to give at this stage is to try to "move about the picture," that is, don't linger around any one component or area of coloring. It's better to make a quick attempt and go back later; in the meantime try to sharpen your creative perception, interpretation, and synthesis.

Third step: completion
The picture is now completed, but there's still room for improvement after checking over a few details: the highlights on some of the fruit including the grapes; the color of the wooden table; and one or two lines and highlights in the tablecloth. The finished work can be judged more easily from the color reproduction on page 103.

Fig. 279. At this stage, the painting is almost finished. Some lines and highlights will still be changed.

Step-by-step painting no. 1

For a better understanding of this step-by-step process, you should compare Fig. 281, the second step of shape and color adjustment, with the reproduction of the finished picture on page 103. Notice the alterations made in the shapes and the colors in some parts of the picture: the complete restructuring of the bunch of grapes; the changes made to the apples in the foreground; and the differences made in the construction and coloring of the tablecloth by using whites and light grays to emphasize the folds. Observe the additional work that was done on the tumbler and the porcelain vase; the shapes and colors of the objects were adjusted at the same time.

Take a careful look at the progress from the penultimate stage (Fig. 279, page 101) to the completed picture (Fig. 282) and notice the finishing touches. If you would like to review the suggestions given in this section, try to paint a still life in a style similar to this exercise, keeping in mind what you know about Cézanne and his work.

280

Fig. 280. The reduced photograph of the model is repeated here to help you study the still life at its final stage. Thus, you can better understand how the process of interpretation and synthesis were carried out to the finished painting (Fig. 282).

Figs. 281 and 282. Compare the end of the second stage (Fig. 281) with the completed painting (Fig. 282). Note how the shapes are more clearly defined through the changes in color. The glass tumbler and the porcelain vase have more detail.

281

Step-by-step painting no. 2

The step-by-step guidance given here includes a couple of important points about oil painting in general and, in particular, still lifes in oils. The picture in question was painted with artificial light and took two evening sessions, about two-and-a-half hours each. Fig. 283 is a photograph of the subject and the table lamp used for lighting it—it's an ordinary 100-watt bulb. My easel was about 5 feet (1½ m) away from my subject; my work was lit by a 100-watt bulb in an adjustable lamp fixed to the easel. The subject and the kind of lighting are important, since the majority of the still life is made up of glass objects against a dark background. Bear in mind these three logical points: Glass is transparent, therefore the background colors or objects directly behind the glass are visible. Secondly, the shapes seen through glass bottles will appear distorted. And third, the portrayal of glass objects consists mainly of dark outlines, dark and light patches, and highlights. Keep these points in mind in your step-by-step painting of this still life.

283

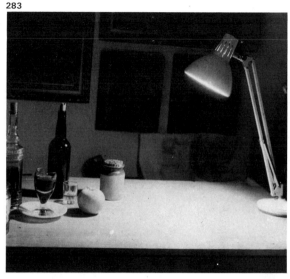

284

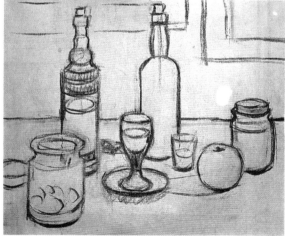

285

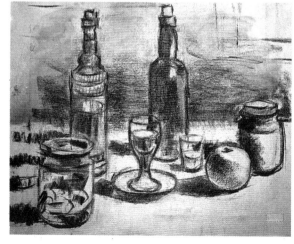

Fig. 283. Photograph of the model used for this step-by-step painting, with artificial light.

Fig. 284. This preliminary charcoal drawing was done after making a few sketches to work out proportions, consider the composition, and check how the subject would fit into the picture.

Fig. 285. Here is the same drawing filled in with charcoal in order to sort out the volume, the shapes, and the projection of shadows.

286

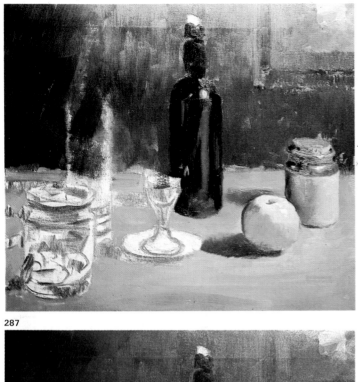

287

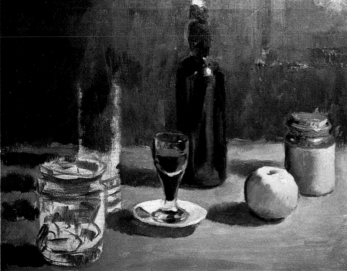

Fig. 286. At this stage, you can see the first applications of color in the background and in the elements of the still life.

Fig. 287. Four elements of the still life have been painted. The apple is the focal point of the composition.

The dark tones of the background and the light sienna color of the table were painted in first (Fig. 286). The bottle was painted directly with a finish that seems more or less final. If you look at the finished picture (Fig. 291), you'll see that the volume of this bottle is conveyed just by the highlights and the reflection of a dim glow from the ochre and yellowish colors of the tabletop and the apple. The dark background blurs the shape of the transparent bottle toward the left and you have a mere hint of its size. The wineglass was not painted in at this stage, and the cork, which was in the actual still life, on the table in the foreground has been left out. Why? Both seemed to complicate the composition.

The apple and the earthenware jar have been painted as they will appear in final stage (Fig. 287). Look at the finished still life (Fig. 291) and notice how the different objects are positioned to make the apple stand out, presenting a sharp contrast that makes the apple the focal point it was intended to be.

When I started to compose this still life, I placed the wineglass where it is now, but left out the white saucer. I realized after the preliminary sketches that the patch of white was needed to provide diversity. In the reproduction of the finished picture on page 107, you can see how the base of the wineglass was synthesized with a few simple strokes of dark grays, light grays, and white highlights. This is a good example of the law of contrasts: "A light color becomes paler in proportion to the darkness of its surrounding color."

Step-by-step painting no. 2

288

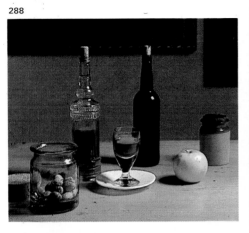

289

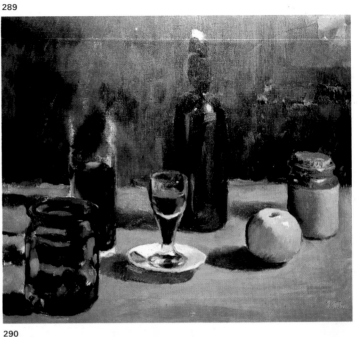

290

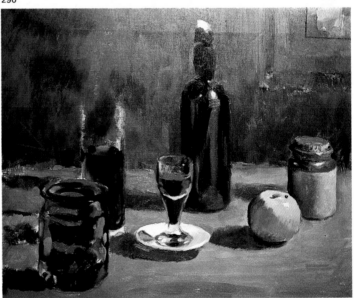

These color photographs of the painting in various stages were taken in my studio. Although tests were carried out beforehand, and the greatest care was taken, it was not always possible to prevent the sheen and reflection of the newly painted canvas in the quality of reproduction. This is evident in Figs. 289 and 290 and is most noticeable at the top of each reproduction. Notice how the background color distorts the top of the wineglass and adds a slightly blue-tinged white in the highlights of the darker bottle.

You may think the glass jar in the left foreground of the picture—with odd transparent patches, vague nutlike shapes inside, distortions, and uneven chiaroscuro and highlights—looks very complicated and is a difficult subject to paint. But it's no more difficult than anything else and requires no special skill. You have to keep in mind Michelangelo's often-quoted precept: "Draw everything; copy everything." In other words, look at each shape, every patch of color, and every highlight as if it were a subject in its own right, analyzing its contours and size in relation to everything else you draw. It sounds straightforward enough.

Here is the final result (Fig. 291) after a bit of retouching: making the background and the table paler, reconstruct-ing the top of the wineglass, and finishing the glass jar and the wine bottle on the left. If you look carefully at the wine bottle, you'll see how the effect of volume is conveyed by merging its shape with the background. A few carefully placed dark patches and one or two light, almost white, flecks show the highlights.

Figs. 288 to 290. Painting glass is a task in synthesis. The texture of the object must be conveyed with a few, but calculated, strokes.

291

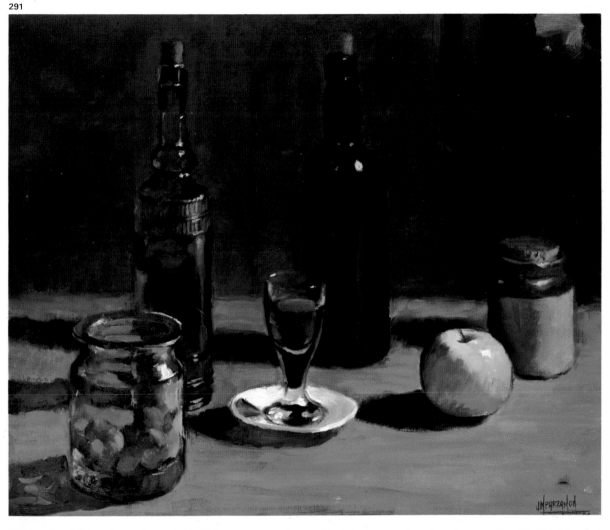

If you look closely at those highlights, you'll notice that hardly any of them are absolutely white. Nearly all the highlights are slightly tinged with the object's color. The highlight on the apple is white. On the earthenware jar, the highlight is white with a tinge of ochre; the small highlight on the left shadowed part has a touch of blue. The highlights on the darkest bottle have a noticeably bluish tone. Some highlights on the clear bottle are very pale gray, some slightly bluish and some pale ochre. And most of the outlines are slightly blurred, especially those in the background.

You may want to try to paint something which presents the same problems as in this exercise—spend an evening or two painting with artificial light. It's a helpful and interesting exercise.

Fig. 291. This is the final result of my still life painted with artificial light. I think it's a good study on light, shadow, and highlights.

Step-by-step painting no. 3

292

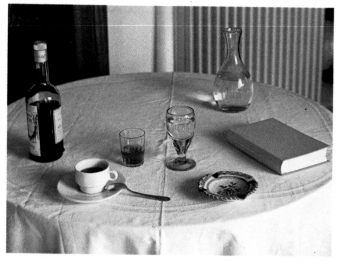

For the final project, I will paint a still life in daylight, using the speed-painting technique. The picture was finished in a single session.

The subject

This is a simple subject, but attractive and interesting: a round table with a white tablecloth on which stand a carafe, a bottle, a tumbler, a wineglass, and so on—perhaps how a table would look after lunch. There's an ashtray (to which I added an imaginary cigarette) and a book. It is a simpler subject than the other two exercises, but in presents its own challenge—you have to use the simplicity.

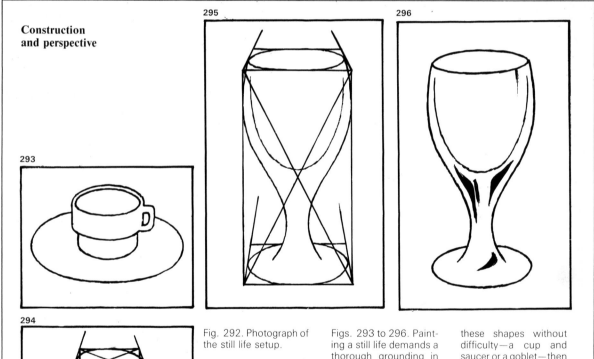

Construction and perspective

293

295

296

294

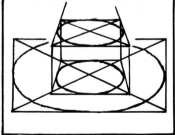

Fig. 292. Photograph of the still life setup.

Figs. 293 to 296. Painting a still life demands a thorough grounding in the rules of structure and perspective using basic shapes—the cube, the sphere and the cylinder. Here, as in the previous still life, the objects are classic shapes. If you think you can manage these shapes without difficulty—a cup and saucer or a goblet—then go ahead and use color as well. But if you're a bit doubtful, you should practice drawing cups, saucers, and goblets over and over again. These diagrams should help.

297

298

299

First step

There's no time to spare. The subject must be drawn and painted at the same time. The construction should be rapid so that the paint is fluid. With that in mind, I paint directly with Prussian blue and raw umber thinned with plenty of turp. The construction should be worked out roughly, finding the size, the proportion, and the position of the objects in the still life and how they relate to one another.

Second step

The first thing I must do is to cover up the bare canvas, in this case by painting in the background and the gray of the tablecloth. I used a no. 24 flat brush to apply the gray, mixed from white, raw umber, and Prussian blue. (For this general coloring stage, all the brushes I used were flat and large, such as nos. 12 and 18.) In Fig. 298, the color of the tablecloth shows through the transparent shapes of the carafe, the wineglass, and the empty part of the brandy glass. The book, ashtray, and cup, which have colors of their own, are set apart; so is the brandy bottle, which is complete except for painting in some details on the label. Now I'll show the highlights in the glass. I may come back to some of the painted parts later. For now I need to make the background color richer and more varied, but most of the shapes and colors are more-or-less done. I haven't cleaned the palette yet, it's still holding the gray mixtures for the tablecloth in case I need to retouch, repaint, or correct outlines or contours.

Figs. 297 to 299. Study these three stages of the still life carefully: Direct construction with a brush (Fig. 297); general coloring to cover up the white of the canvas (Fig. 298); and adding the first values to the elements (Fig. 299).

Step-by-step painting no. 3

300

Fig. 300. Detail of completed still life. Notice the synthesis of color and shape.

Fig. 301. In this finished still life, you can see the quick, sure strokes that help emphasize the shape of the objects.

301

Third step

Now for the book, the wineglass, and the small tumbler. I used nos. 6 and 8 brushes to paint the wineglass, the larger brush for the darker grays and the smaller one for the medium grays. Here, as in all the components of this still life, the painting and drawing were done at the same time. You need determination for this act—a certain boldness and self-confidence is vital if you are going to combine drawing and painting with no hesitation, since construction and, indeed, the whole shape of the work emerges straight from your paintbrush. I painted the cup, saucer, and spoon in just a few minutes, concentrating really hard to get the best possible synthesis of shape and color. You'll see this more clearly in Fig. 300, an enlarged detail showing the coffee cup with its saucer and spoon. I found that I had to spend a lot of time—about half an hour—on the ashtray with the imaginary cigarette because there wasn't one handy. This called for meticulous treatment and took longer than anything else, mainly because all the other objects are easily recognizable shapes, even by the time they were drastically simplified. The ashtray had to be more clearly defined and painted in more detail.

Fourth and final step

Here's the finished picture. There was very little left to do, but when I was completing the painting, I noticed a fault: a lack of symmetry in the outline of the round table. Its shape had to be adjusted by correcting the curves. I did this without looking at the model; it was a question of symmetry and geometry. A bit of minor retouching of detail was necessary before I could bring the painting to its final state. Total timing: three hours and twelve minutes.

The dedicated spirit

"I have vowed that I will die painting."
In August 1906, six weeks before his death, Cézanne wrote to his good friend Emile Bernard: "I still study Nature constantly. I still paint; perhaps I am making a little progress. I feel very lonely and I am old and sick, but I have vowed that I will die painting."

The words are poignant but inspiring; they stem from true genius. But genius can be made—it is not always born. Arthur Schopenhauer wrote, "An individual may possess the quality of genius because of the way he works. He is completely immersed; his art almost swamps him. The thought of inspiration is rejected; his faith in hard work is a life-long companion."

The achievement of something good—in painting or any other art—is based on effort. Real brilliance belongs to a great master like Cézanne. But simple good painting comes from hard work, together with the humble and dedicated spirit of artists such as Cézanne, Degas ("I was born to paint"), or Ingres who, at eighty-six, set himself to the task of copying a Giotto fragment. Someone asked him (it was a year before his death) why he was doing that. Ingres's reply was simple: "I must learn."

302

Fig. 302. Paul Cézanne (1839-1906), *Self-portrait,* Orsay Museum, Paris.

North Berwick, a little farther up the coast from Dunbar

Paisley Abbey, where the young Wallace once worshipped